Glass

For Alison.

Glass

Materials for Inspirational Design

Chris Lefteri

RotoVision

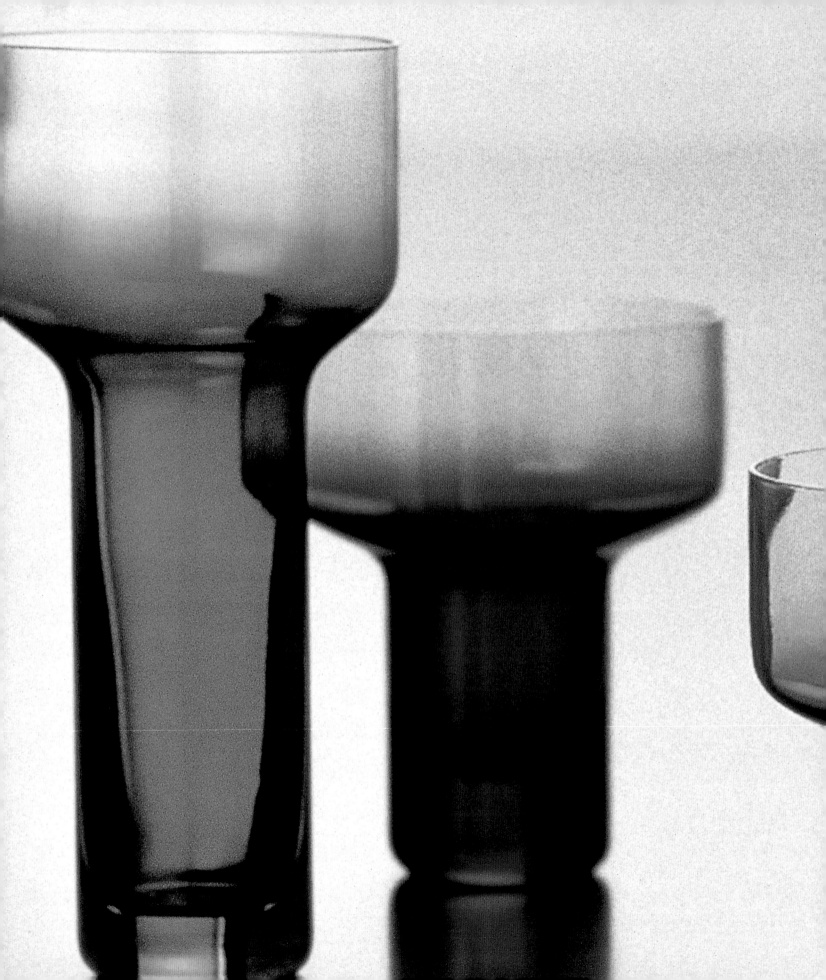

A RotoVision Book
Published and Distributed
by RotoVision SA
Route Suisse 9
CH-1295 Mies
Switzerland

RotoVision SA
Sales and Production Office
Sheridan House
112–116a Western Road
Hove, East Sussex BN3 1DD, UK
Telephone: +44 (0)1273 72 72 68
Fascimile: +44 (0)1273 72 72 69
E-mail: sales@rotovision.com
Website: www.rotovision.com

10 9 8 7 6 5 4 3 2 1

ISBN 2-88046-569-9

Original series concept by Zara Emerson

Book designed by Frost Design, London

Printed and Bound in China by Midas Printing

Contents

Foreword	008 – 009
Preface	010 – 011
Making	012 – 039
Blown	040 – 057
Stock	058 – 079
Techno	080 – 093
Flat	094 – 105

Architectural 106 – 129

Coating 130 – 139

Technical Information 142 – 145

Types of Glass 146 – 150

Website Directory 152 – 155

Credits/Acknowledgements 156 – 157

Index 158 – 160

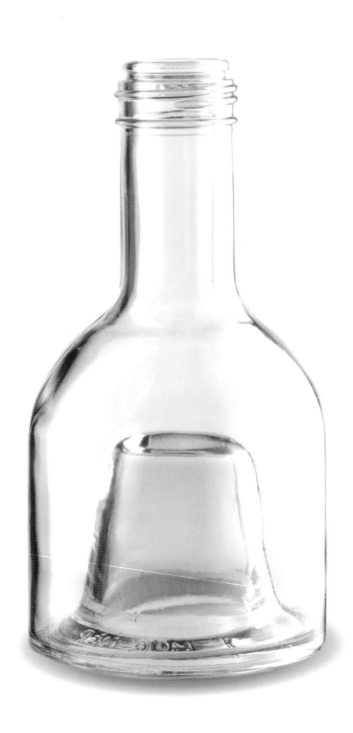

It is not so much our discovery of new materials that drives innovation, enriching our culture and identity, but more how scientists, designers, craftspeople and architects interpret these materials to find new uses and ways to transform them. Even though the science of materials is still in its infancy, we are reaching a stage where physical barriers are being broken down and re-formed: where traditional archetypes are being re-evaluated. Classifying materials is no longer as straightforward as merely grouping plastic, glass or wood for example. New composites are continually being formed leading to new products with fresh applications in ever-changing contexts. It is impossible to discuss this incredibly exciting time in the evolution of materials without reference to the uses and forms to which they have been applied.

Foreword

The evolving science of materials is fascinating, but the way in which we innovate and form with these new characters — from the microscopic to the architectural — is even more so. It is on these levels that the modern hybrids are being formed: where one material strengthens another or, in the case of fibre optics for example, where different types of glass work together. The discovery of a new formulation of glass paved the way for the development of fibre optics, but it was the ability to manipulate this 7000-year-old material and form it into ultra-thin, flexible strands capable of carrying light over several kilometres that really developed our methods of communication.

Other more everyday inventions also owe their popularity to the manufacturing technology used to process them. Thomas Edison's tungsten lightbulb was a remarkable development — however, it cannot be separated from the process of forming millions of lightbulbs cheaply and efficiently. The invention of glassblowing, which, in terms of the history of glass is relatively new, was a milestone in production. It has since been used to produce a multitude of products. The sense of wonder in glass is not so much in the material itself but more in how we have adapted and applied it in so many areas and how it exists in ways you would never have imagined.

Glass is the second in this Materials series, following the hugely successful Plastic. We will continue to explore materials and their modern hybrids and present the products and processes we discover in a unique and exciting format. Informative and accessible, with descriptions of each material's general characteristics, uses and production methods, with outstanding colour photographs, this series is a celebration of these miracles of evolution and technology — an exploration of objects and materials that have been around for thousands of years, as well as a journey towards those which are, as yet, undiscovered.

Take 180 parts of sand, 180 parts of ash (from marine plants) and five parts of chalk. Melt together. The result is an amazing liquid. Glass is a humble material, not as youthful as plastic nor with as exotic a range as wood; it lies like a servant waiting to be formed into whatever we desire. It is free of the intimidating, complex language of plastic but can boast a similar level of advanced technology. Glass is a friendly, more obvious material with less to hide than say, metal – but don't be fooled by familiarity – there is a wealth of complex secrets still to be discovered.

Glass is also a material of contradictions – it has moments where it beckons to be adored and others where it silently and humbly provides a crucial function. It has thousands of decorative applications, as well as acting as an invisible partner to other materials, lending strength and stability. It has been used for thousands of years and continues to be used in some of today's most technologically advanced applications. It can be harder than steel yet wearable. It supports buildings yet can be as thin as a piece of paper, and as flexible as a blade of grass. It can take months to create a delicate piece which can be smashed in a split second, but it also protects space shuttles re-entering the earth's atmosphere.

So here begins the second book in the Materials series. This time the focus is on an older material, possibly one of the first to be manipulated on a large scale. This translucent, hard material is amazing, not least due to the surprises it offers. It is one of the most versatile materials in existence, used for such opposing functions as an inert packaging material for fine wines, to replacement body parts. This book offers a broad selection of the most fascinating, decorative and functional types of glass and glass products.

It is impossible to separate any material from its production methods. With glass, the methods of production are even more relevant because there is little physical difference between most of the types of glass that we encounter every day. Defining and categorising glass is no easy task – there are hundreds of different types. In the end its ability to be processed and its varied forms differentiate it.

Glass has evolved hand-in-hand with new forming methods. Although the exact date when glass was first discovered is a mystery, it is known to have been used around 4000 BC as a glaze for beads. One of the oldest production methods is core-forming, believed to have been practised around 1500 BC. This involved forming mud, clay or a similar substance around a metal rod. Heated glass would then be wrapped around this form and once the external shape had been defined and cooled down, the natural core was scrapped out leaving a hollow form. The introduction of the blowing iron in the first century BC had a monumental impact on glass production; it could now be blown, resulting in the kind of hollow vessels we are familiar with today. Glassblowing produced the first glass windows, made by blowing a bubble of glass and then, while still hot, spinning it until the force produced a flat disc. This could then be cut into square panes. The limited size of these discs meant that windows were made up of a series of small panes set in wooden frames.

Glass has always been truly remarkable in its ability to take on unexpected forms and applications. The 20th century has given birth to even more surprising processes and forms of glass. By exploring a selection of everyday objects and introducing some of the more unusual glass products, I hope to educate and inspire – as well as encourage curiosity and interest in this wonder material of the past, present and future.

Preface

How to use this book

This book is not an historical analysis of glass — it is more a manual and introduction to a range of glass materials, applications and processes. The Materials series aims to inspire anyone and everyone — from students and professional designers, to artists and enthusiasts; from those with just a passing interest to those who are already well informed. Glass is not intended as a chronology of the material, but instead offers contemporary examples of glass in its various incarnations, from the highly decorative to the microscopic and purely physical uses.

The book is divided into two sections. The first deals with specific products, materials, processes and applications — the chapters loosely grouping products together under these themes. The text is deliberately non-technical. My purpose is to inform in a common language which may suggest new ideas for materials and products, rather than swamping the page with technical information.

This book is an introduction to glass. It will not supply you with everything you need to know about the material, nor does it include every form of glass. The tables on each page give pointers to further information. These details may not necessarily be the product or process described but instead provide suggestions for further research. The contact details given on each page serve as a guide only — in most cases there is more than one supplier. Also included on each page is a guide, cross-referencing to subjects on other pages. On most pages you will find 'key features' that break down the material into its basic properties (these are not relevant in all cases). 'Typical Uses' helps to contextualise the material by suggesting other applications. The appendices provide a broader reference guide including glass websites and organisations. There is also a technical table and a glossary of technical terms. Have a good read.

013 Making

014

Dimensions	**12mm thick crystal glass**
	Height 680mm x width 950mm x depth 750mm
Material Properties	**The Fiam pieces require massive investment in**
	large curving chambers and CAD equipment
	for the water-jet cutting. However, the process of
	slumping glass on a smaller scale is relatively
	inexpensive if a kiln is available
Further Information	**www.fiamitalia.it**
Typical Uses	**Magazine racks; tables; chairs; tableware;**
	any product using flat glass

Ghost Chair
Designers: Cini Boeri
and Tomu Katayanagi
Produced by: Fiam
Designed: 1987

Elastic

There is something especially intriguing about slumped sheets of glass. The once flat sheet takes on a new form by heating and relaxing it over a mould ➘ – much like pastry draped over a tin. The stiffness of the glass at this extra thickness allows for new forms and structures to be created.

The Ghost Chair, designed by Fiam in 1987, has become an icon. It exploits the two main production processes – water-jet cutting ➘ and slumping. The formability of the heated glass sheet is demonstrated in this relaxed fluid form that looks as though it could have been created by chance. But the apparent simplicity of the Ghost Chair hides a complex and highly controlled heating process – modern, sophisticated technology combined with the simple process of forming.

more: Moulds 018, 026, 033, 036, 046, 048, 051, 054–055; Water-jet cutting 034–035

No moulds

Used more as a low- to medium-volume production process, lampworking ↘ involves heat being applied to a piece of glass locally before usually being formed by hand. Because the flame can be directed at specific points on the object, the glassmaker has a high degree of control and accuracy, which is difficult to achieve through glassblowing.

It is not known exactly when lampworking was first used as a production process. If core-forming is considered as a type of lampworking then it dates back to the ancient Egyptians. Soda-lime glass ↘ was used for lampworking until the 1920s when the more resilient borosilicate glass ↘ was invented, which gave this method of production a new lease of life. This tougher material allowed for glassware to be heated and cooled quickly and was more resistant to physical shock, which made it an ideal material for laboratory applications.

While in residency at the National Glass Centre, Jhan Stanley made this set of borosilicate cutlery to draw attention to the traditional process of lampworking.

more: Lampworking 038, 044, 063, 076; Soda-lime glass 023, 046, 052, 055, 061, 068, 074, 076

Dimensions	Oil & Vinegar Container: 170 x 100mm
Material Properties	No investment in tooling
	Selective heating of object allows for accuracy
	Due to localised application of heat, energy requirements are a fraction of glassblowing
	Allows for one-off pieces or large production runs
Further Information	www.global-flamework.com/history.htm
	www.hotglass.com, www.jhanstanley.co.uk
Typical Uses	Scientific instruments; decorative figurines; thermometers; oil and vinegar containers; beads; flower ornaments

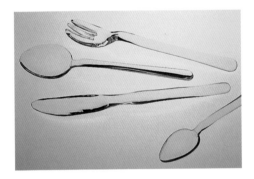

Twisted Glass Cutlery
Designer: Jhan Stanley
Concept project
Launched: August 2000

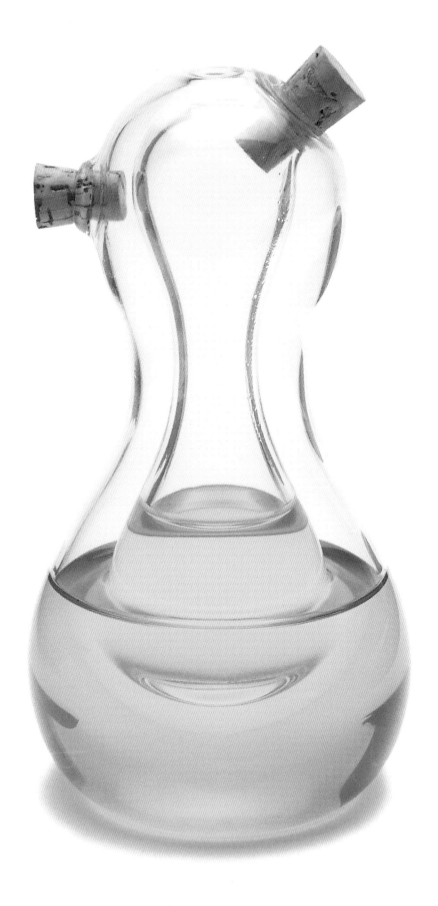

Oil & Vinegar Container
Designer: Tony Papaloizou
Launched: 1998

more: Borosilicate glass 049, 052, 062–063, 067, 069, 074, 076–077, 105, 132

018

Handmade

Dimensions	**100 x 240 x 150mm**
Material Properties	**Good for large complicated forms**
	Expensive
	Used where thickness and solidity are needed
	Provides good detail
Further Information	**www.nationalglasscentre.com**
Typical Uses	**This process is highly labour-intensive and so is limited to batch production of studio art glass**

The term 'cast glass' ⬎ can refer to a range of different processes. The lost wax method is used largely in studio art glass. As with so many handforming techniques, the final piece reveals only the tip of the iceberg. The production of a piece can involve a number of processes, which have to be successfully completed before the glassmaker can move on to the next stage.

Emma Woffenden's Probe Series exploits this method. Rubber moulds ⬎ are taken of various parts of a child's body. A solid core is then created from an investment material. Next, a wax model of the outside form is made and the solid core is pushed into it. A reservoir of cullet is supported over the top of the mould and heated in a kiln. The wax is then melted out by the glass, which takes its place in the mould. The rough texture, which the piece exhibits when it comes out of the mould, is polished to a smooth finish.

Probe Series
Designer: Emma Woffenden
Private commission: 1999

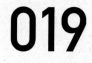

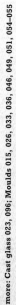

↑ more: Cast glass 023, 096; Moulds 015, 026, 033, 036, 046, 049, 051, 054–055

020

Colour-sequencing

Amy Cushing's fused glass ⊾ pieces rely on a highly scientific recipe to create a unique range of colour ⊾ combinations and colour-changing pieces. Amy's company Mosquito™ combines this very controlled working method with a personal aesthetic that embraces materials and colour.

Melting and blending glass is one of the oldest forms of natural glass production. Amy begins by working cold with a palette of 20 colours. Threads, rods ⊾ and strips are layered over a clear sheet of glass, which is then fired and re-worked by cutting, finishing and firing again, up to four times. From the original 20 colours endless colour combinations are produced. But the real skill lies in methodical experimentation, which gives a certain degree of predictability. Each piece of glass has to have the same expansion rate to avoid cracking in the kiln, and colour change and temperature is noted. Amy's blended experiments demonstrate the full potential for fused coloured glass.

Dimensions	**200 x 200mm**
	Maximum size for single piece 500 x 500mm
Material Properties	**Allows for detail in small pieces**
	Can also cover large areas
	Infinite variety of colour
	Low tooling costs
	Production volumes limited by handmade process
Further Information	**www.nationalglasscentre.com**
Typical Uses	**Wall tiles; tableware; platters; dishes;**
	partition walls; hanging installations; jewellery

Detail from fused wall piece
Designer: Amy Cushing
with Ella Doran
Launched: 2000

more: Fused glass 111, 123; Colours 028, 030, 033–034, 138; Glass rods 033, 062

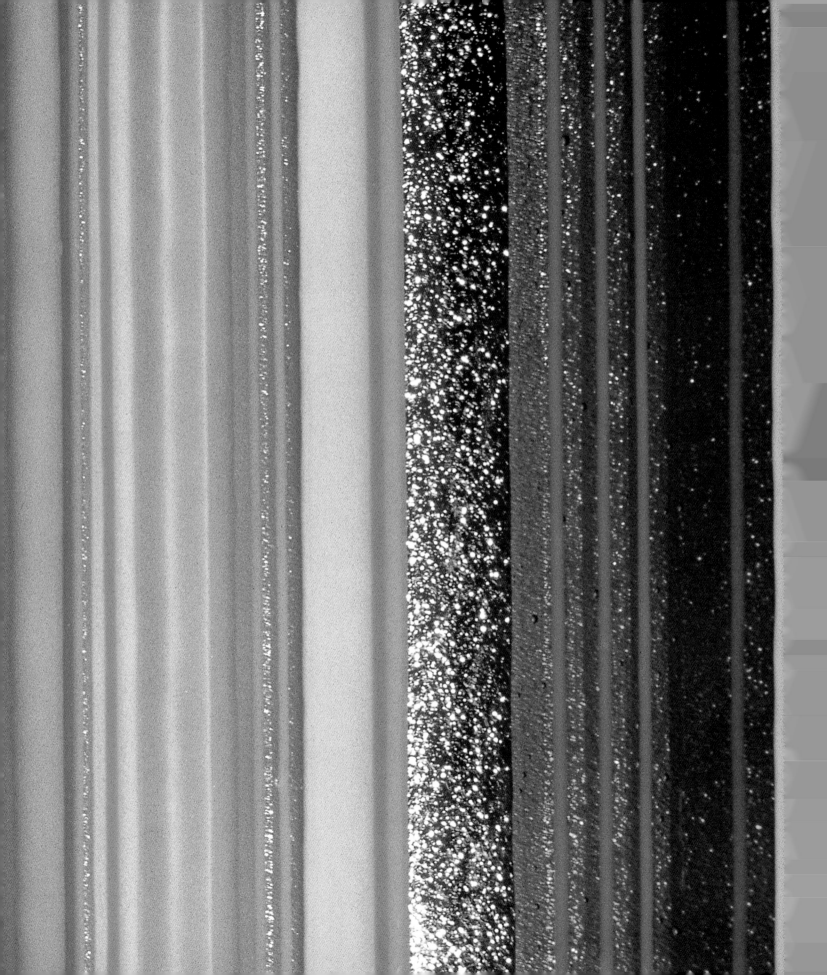

Cat friendly

Dimensions	**100 x 160 x 90mm**
Material Properties	**Long cooling process compared to other methods**
	Well suited to thick-walled products
Further Information	**www.harrikoskinen.com**

Glass takes on a thick, syrup-like form when heated. As it cools it takes on the exact form and surface detail of its mould. This simple practice is one of the oldest glass production methods that dates back to the ancient Egyptians, if not further. The Block Lamp, a thick, heavy, solid form, with a sandblasted ⬎ internal shape, makes a direct reference to this ancient technique.

The idea for the Block Lamp, which is made from standard soda-lime glass ⬎, was conceived by Harri Koskinen during a sponsored college project at the University of Art and Design in Helsinki. He examined cast glass ⬎ as a specific production process and economised by using one graphite mould to create two identical parts. The original design was easily reproduced in a small batch of 50 units. When the rights were acquired by the Swedish producer, Design House, production naturally increased and the lamp has since been mass produced. A maximum wattage of 25W is recommended so that the lamp does not get hot, but just warm enough for cats to fight over who gets to sit on it, which, according to Koskinen, is a common problem if you have more than one cat.

Block Lamp
Designer: Harri Koskinen
Produced by: Design
House, Stockholm
Designed: 1995

more: Sandblasting 025–026, 028, 100, 103, 116; Soda-lime glass 016, 046, 052, 055, 061, 068, 074, 076; Cast glass 018, 096

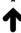

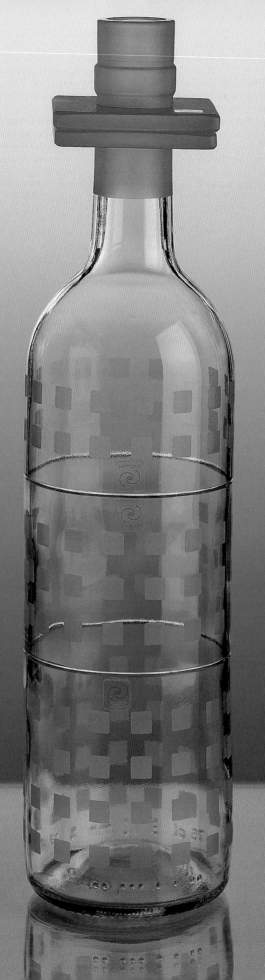

The Double Life of a Wine Bottle
from the Evolum Range
Designer: Jukka Isotalo
Launched: 1989

Cold-Worked Recycled Bottles

025

Re-use

Started as a project in 1989 as a result of the 'economical and ecological crisis', Jukka Isotalo's bottles explore the possibility of cold-working glassware by the economical recycling ↘ of found bottles to create original products with new functions.

'I started to make these products in 1989 while I was studying as an exchange student at the University College of Arts, Crafts & Design in Stockholm, Sweden. I didn't have enough money to travel to Finland for Christmas and I was quite fed up with the material overload the world was, and is, suffering. I noticed all the bottles we had in our studio in the glass department. I decided to tackle the economical and ecological crisis at the same time and made some vases out of bottles for the Christmas bazaar. They were a big success.'

All of Jukka Isotalo's products are handmade from non-refillable bottles and surplus glass from glaziers' shops. Sandblasting ↘ provides decoration and no acid-etching is used. This range is an example of how creative solutions can arise from the most restrictive situations.

Dimensions	Evolum Range: 300 x 100mm
Material Properties	Low tooling but labour-intensive
	Ecological use of material
	Ecological production
Further Information	jukka.isotalo@evolum.fi; Tel: +358 (0)9 8240 3000
	Pengerkatu 29, 00500 Helsinki, Finland
Typical Uses	Decoration; storage

more: Recycled glass 055; Sandblasting 023, 026, 028, 100, 103, 116

026

Textured water

more: Moulds 015, 018, 026, 033, 036, 046, 049, 051, 054–055; Kiln-cast glass 109; Float glass 073, 103, 110, 136; Sandblasting 023, 025, 028, 100, 103, 116

Contained in every piece of glass is the latent ability to take on a new identity. Smooth, sleek and flat polished glass can be contorted into heavy, delicious textures. To provoke this transformation, heat and a mould ⊿ are needed.

Kiln-cast ⊿ is a process of forming float glass over refractory moulds to create textures and patterns on the surface of a piece of glass. With the range of surface effects that can be created, kiln-cast glass is becoming an increasingly common material within contemporary architecture and interior design.

Standard float glass ⊿ is laid over ceramic, sand, plaster or concrete moulds depending on the desired texture and effect. When heated the glass relaxes over the moulds to pick up the forms and texture. It is then slowly cooled and annealed. This can take anything from 12 hours to a week depending on its thickness and size.

As with any production process that uses moulds, prices reduce according to the number of final units. Casting produces sheets with a depth of approximately 100mm which can then have a range of colours and finishes applied such as mirroring or sandblasting ⊿ .

Cast glass not only allows for new visual organic, rhythmic and geometric possibilities, but also provides a great tactile surface that makes you just want to touch.

Dimensions	Available up to a maximum size of 3150 x 1750mm in 4–25mm thickness in float glass
Material Properties	Endless possibilities for decoration
	Can be bent or curved; One-off or batch produced
	Low tooling costs for one-off pieces
	Handmade process
	Cost-effective compared with other decorative materials
	Good range of possibilities for coatings
	Can be toughened or laminated to British Standard 6206
Further Information	www.fusionglass.co.uk
Typical Uses	Partitions; doors; screens; commissioned features; flooring; signage-cladding; balustrades; counters; lighting; furniture; sculpture

Kiln-cast glass
Designer: Fusion Glass
Designs Ltd.
Launched: 1997

028

3D-frosting

Perfect for decorating any type of flat or formed glass, sandblasting ⬃ is also an economic way of creating a surface effect for one-off or batch-produced products. This process is not limited to flat patterns but can also be used to create deep recesses and cut holes. Colours ⬃ can be introduced by adding a pigment.

To achieve this permanently frosted effect, tiny particles of grit and air are sprayed on to the surface resulting in fine scratches. Elaborate patterns can be created using a stencil, and in the hands of a skilled craftsman, sandblasting can create delicately shaded areas. The introduction of a clear coating to protect the surface has meant that greasy fingerprints which would normally be left on a sandblasted surface are no longer a problem — making it a viable alternative to acid-etching ⬃ but with less subtle detailing.

more: Sandblasting 023, 025–026, 100, 103, 116; Colours 020, 030, 033–034, 138; Acid-etching 139

Dimensions	Maximum sheet width: 2286mm or, as Glacien Glass suggest, 'any size as long it fits through the door'
	Maximum recommended depth for deep sandblasting: 5mm approx
Material Properties	Excellent potential for surface decoration
	Can be applied to flat or formed glass
	Permanent; Flexible working process
Further Information	www.glacienglass.co.uk; www.glass-design.com
	www.taylorsglass.co.uk; www.glassco.co.uk
	www.pilkington.com
Typical Uses	Doors; shower screens; furniture; tableware; protective barriers

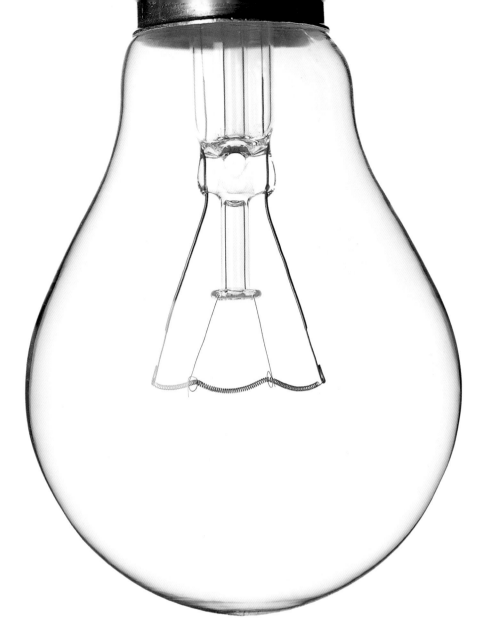

It is not enough to have a great invention without the technology to produce it at the right price for the consumer. Thomas Edison invented the lightbulb in 1879 but for it to become truly usable, a particular glass was needed to withstand the temperatures the filament would produce. The glass also needed to allow for a low-cost and high-volume reproduction process.

Before the ribbon machine process was invented in 1926 by Corning, glass envelopes for lightbulbs were handmade at a rate of two per minute. Once this new technique was perfected, 2000 lightbulbs could be produced per minute. This high-speed continuous process uses a linear production line, which involves a ribbon of glass passing over a series of holes in a horizontal metal plate. The semi-molten glass sags at the holes and a puff of compressed air forces the glass into a mould.

The common, everyday lightbulb is an example of a material and production process working in partnership to the point where one cannot be separated from the other.

Dimensions	104 x 60mm
Material Properties	Large tooling investment
	Extremely high production rate
	Low unit cost
Further Information	www.asme.org
	www.cmoq.org

Inseparable

60W Tungsten Lightbulb
Ribbon machine invented by:
William J. Woods with David E. Gray
First produced: 1926

030

Hard and unique

The clear glass marbles with twisting swirls of colour ⬎ embedded in them are the result of a simple process which can produce 14–16 million unique pieces per day.

To mass produce marbles, molten glass is extruded into square or round canes. These lengths are then snipped into small, regular-sized pieces which are dropped on to a series of interlocking, threaded rollers. As they pass down the length of the rollers they are gradually rounded off into spheres and simultaneously cooled. The spiral pattern in clear marbles results from coloured glass being blended with the rods before being sheared off into small pieces. The internal swirling shapes result from the canes constantly turning over on the rollers.

Marbles are one of the oldest toys known, and date back to the ancient Egyptians who buried them in tombs for use in the afterlife. They are also mentioned in ancient Greek literature. The earliest marbles were made of clay, wood, stone and other hard materials. Glass marbles were not introduced until the mid-20th century. Today there is a healthy collectors' market of both machine and handmade marbles all over the world.

Material Properties	High volume production
	Every piece is unique
	Very cheap unit costs
	Durable
Further Information	www.megamarbles.com/index.html
	Teign Valley Glass, Newton Abbot, Devon, UK
	Tel: 01626 835358

more: Colours 020, 028, 033–034, 138

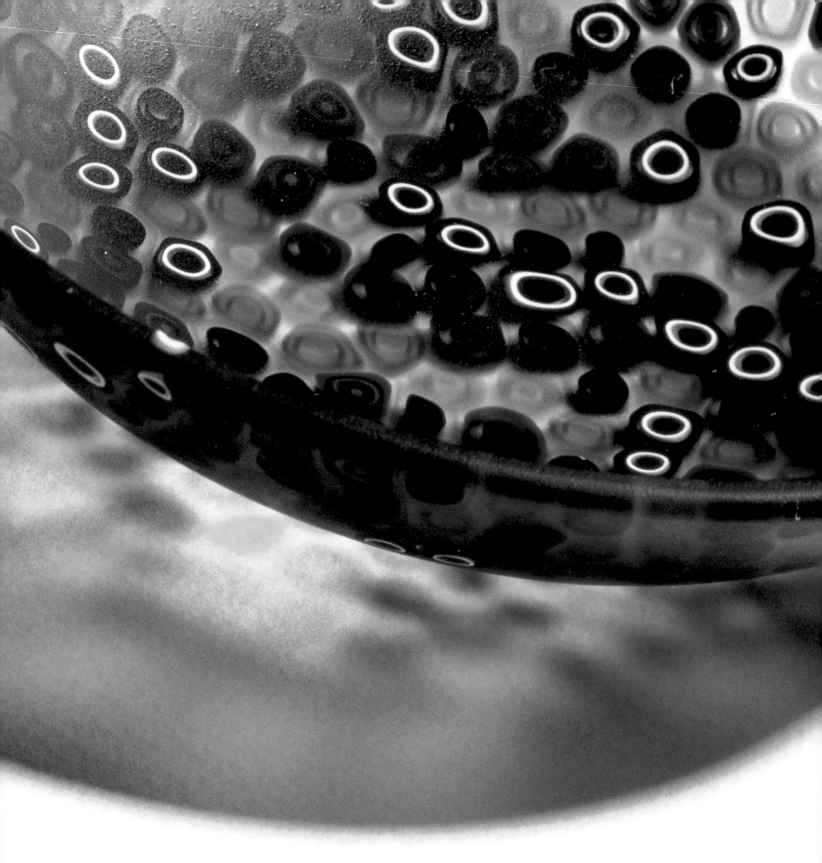

Murano Glass Bowl
Produced by: Murano Glass
Designer: Unknown
1000-year-old technique

These multi-coloured bowls ◥ are the result of a process that is over a thousand years old, the Millefiori (1000 flowers) technique, whereby objects are produced using thinly sliced multi-coloured sections of glass.

To make a Millefiori bowl you will need:
A kiln or glass-melting furnace
Flat ceramic plates (for fusing)
Dome-shaped ceramic form for slumping
Pincers; Shears
A long-handled tool for transporting the plates and forms in and out of the furnace

• First, make the rods ◥. Pre-heat your kiln. Heat some glass and stretch it out into strips — do this with a number of colours.
• Roll the strips together into a sausage roll shape about 50mm in diameter. To achieve the thinness of the final rods (some are just 1mm) you will need to stretch the roll at both ends, which will depend on the size of your bowl. This should all be done while the glass is still hot.
• Once you have made your rods, allow them to cool enough to be picked up. Cut these rods into short lengths (about 5mm) and arrange them into a disc on your ceramic plates and re-heat long enough for the pieces to become soft. Press the pieces flat and squash them together to remove any gaps and re-heat until they have fused together and the glass pieces can be handled as a single sheet.
• To form the bowl place the soft sheet over your ceramic mould ◥ and place in the kiln until it softens enough to form a smooth shape over the mould. Take the mould out and remove the glass bowl. Once the glass is cooled you can grind and polish if you wish.

Dimensions	130 x 80mm
Material Properties	Unique decorative outcome
	Low tooling costs
	Low- to medium-scale production volumes
	Small alterations can be made to each product
Further Information	www.langfords.com
	www.doge.it/murano/muranoi.htm
Typical Uses	Tableware; bowls; ornaments; dishes; plates

Fused mosaics

more: Colours 020, 028, 030, 034, 138; Glass rods 020, 062; Moulds 015, 018, 026, 036, 046, 049, 051, 054-055

For this installation at the Leeds City Gallery,
Zara Maltman created a visual playground of
clear, transparent, opaque, translucent and
coloured ⬎ glass. This project looks at water-jet
cutting ⬎ and the use of coloured glass,
focusing on perception and views — transparent
and opaque.

The Stevens Architectural Glass Competition
is a national competition run by the Worshipful
Company of Glaziers and Painters of Glass.
The brief was to design a glass dividing wall
to be viewed from both sides at the Leeds City
Gallery, separating the new education room
from the café area. This gave Zara the
opportunity to explore her theme.

Communicating ways of seeing, the wall is
designed to invite visual and physical exploration
at close quarters. Different sections have
varying visual qualities: for example, looking
through the rods offers a distorted and highly
coloured view of the world on the other side of
the screen. There are occasional spots of small
but completely clear windows — other areas
appear to offer a view through the glass, but
turn out to be visual dead ends. The mixing
of surface and colour casts fascinating and
ever-changing shadows on the viewer's side
of the glass.

more: Colours 020, 028, 030, 033, 138; Water-jet cutting 014–015

View One: partition wall for
Leeds City Gallery
Designer: Zara Maltman
Installed: 2001

Dimensions	Two sections 2440 x 4170mm & 2440 x 3170mm
Material Properties	Ideal for cutting flat sheets
	CAD-compatible
	Intricate shapes
	Cost-effective to set up
	No tooling
Further Information	www.maltman.fsnet.co.uk
	www.many-colouredglass.co.uk
Typical Uses	Water-jet cutting is used to make a variety of household objects: mirrors; accessories; furniture

Visual feast

036

Patterned surface

Pressed glassware ↘ was first used in the early 19th century in the USA to produce furniture handles and quickly became one of the most important production innovations since the introduction of glassblowing. One of its main advantages over blowing is its ability to produce fine detail on both the inside and outside of an object.

The basic process involves a gob of glass being squashed between an inner and outer mould ↘. The thickness between these two parts controls the thickness of the final glass piece. The inner and outer mould allows for this control and definition to be achieved on both surfaces. Its main disadvantage over blown glass products is that closed container shapes cannot be produced. The only requirement of any pressed shape is that the opening has a greater width than the base.

This process tends to produce robust, thick-walled products. The dimples and points in this common lemon squeezer perfectly illustrate the pressed glass technique.

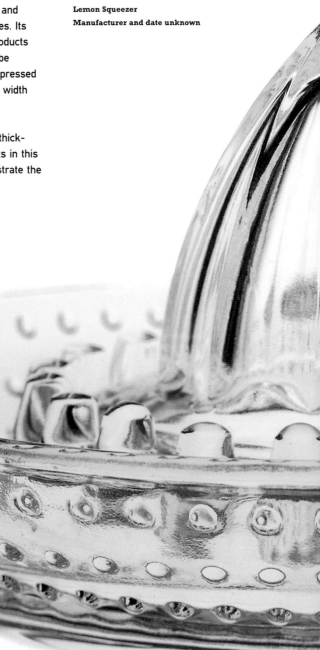

Lemon Squeezer
Manufacturer and date unknown

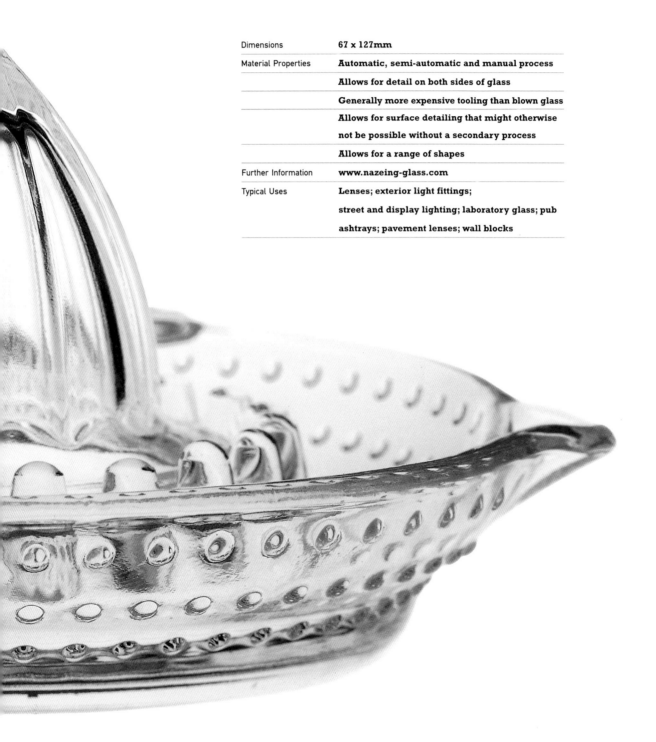

Dimensions	67 x 127mm
Material Properties	**Automatic, semi-automatic and manual process**
	Allows for detail on both sides of glass
	Generally more expensive tooling than blown glass
	Allows for surface detailing that might otherwise not be possible without a secondary process
	Allows for a range of shapes
Further Information	**www.nazeing-glass.com**
Typical Uses	**Lenses; exterior light fittings; street and display lighting; laboratory glass; pub ashtrays; pavement lenses; wall blocks**

more: Pressed glass 123; Moulds 015, 018, 026, 033, 046, 049, 051, 054–055

038

No longer just a part of seedy window displays, neon tubes are being taken into new territories. These intriguing, intestinal objects are created from a specific production process and materials to produce a unique language of form.

The continuous line of these structures is made by lampworking ⬎ a variety of coloured glass canes with a wall thickness of about 1.2mm in lengths of about 1.5m. Once the shapes have been formed, electrodes are attached to either end of the loop. The piece is then placed in a vacuum where impurities are burnt out and a combination of neon, argon and mercury gases are added. Once the object is complete the ends with the electrodes are slotted into the base where the transformer is located.

Some of the most interesting objects feature a special Plasma Neon technology which creates a mesmerising, moving cloud of gas in the tube — making the colours change according to the ambient temperature of a room. These techniques allow for specific forms to be handmade by just about anyone who wants to find an application or just plain likes them as they are.

New potential

Dimensions	500–2500mm tall
Material Properties	**Highly distinctive**
	Can be made to any design
	Low tooling and set up costs
	Can be incorporated into logos and artwork
Further Information	**www.futuraneon.co.uk; www.bar-m-eats.co.uk**
Typical Uses	**Lighting; interior decoration; signage;**
	sculptural forms for interiors and exteriors

People Sculptures
Designed and produced by:
Rocco Borghese
Launched: 2000

more: Lampworking 016, 044, 063, 076

041 Blown

Sumo wrestling

'I've never done anything like the Floats. They are probably the most monumental-looking since there's no reminiscence of a container shape. Just because they are so big, the Floats are technically, or let's say, physically, the most difficult things that we have ever done. Even though a sphere or a ball is about the easiest form you can make in glass, when you get to this scale, up to 40 inches in diameter, it becomes extremely difficult.' Dale Chihuly

Compared by the main glassblower in this project, Richard Royal, to being like sumo wrestling with 'lots of preparation then a short burst', these massively heavy glass balloons are on such a scale they require a team of blowers to produce them.

The size of these pieces is extraordinary. These giant spheres are produced by a crew of ten people and are some of the largest free-blown forms ever made. The process begins 45 minutes prior to blowing, when the glass is gathered. Once the glass is ready, extra long pipes on rollers are used to help carry and turn it. The biggest problem is blowing and controlling the form in 20 to 30 seconds, which, due to the scale, uses a combination of mouth-blown and compressed air.

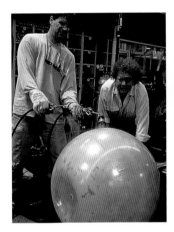

Float Series
Designer: Dale Chihuly
Installation on Niijima, Japan
First produced: 1987

Dimensions	Diameter range: approximately 30–100cm
Further Information	www.chihuly.com

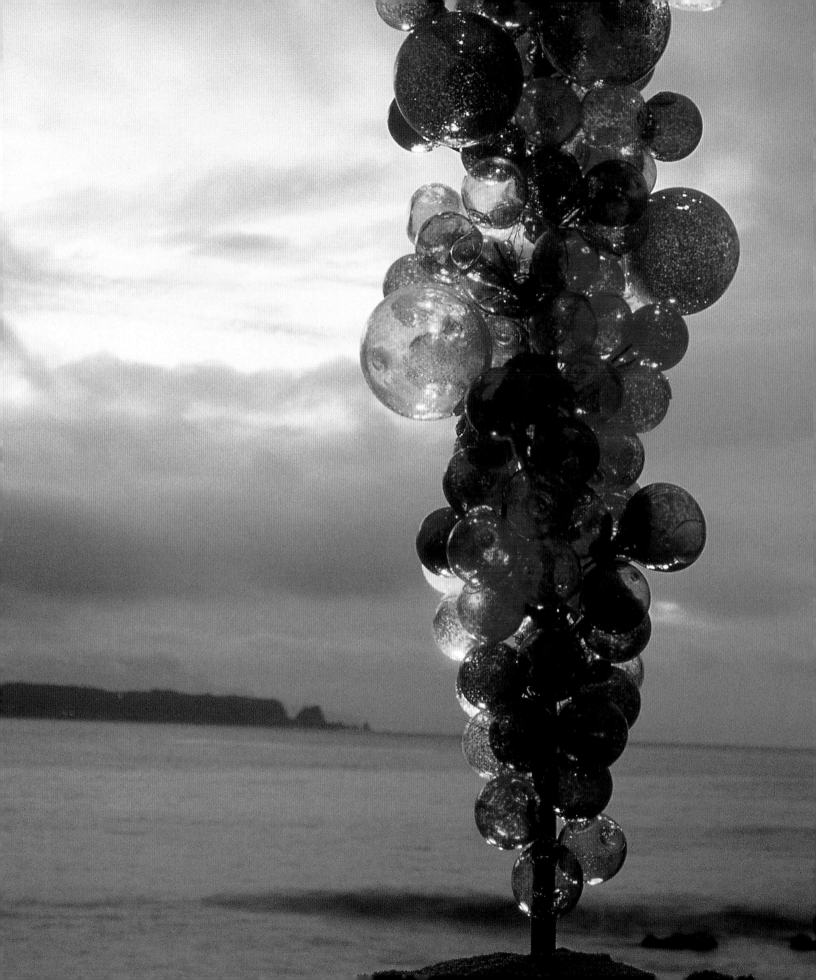

044

Glass eyes

Although there is strong competition from acrylic, glass still features prominently in optical prosthetics. The history of replacement eyes can be dated back to the Egyptians and Romans who wore eyes made of painted clay attached to the outside of the socket with cloth. The Egyptians also replaced the eyes of the dead. The Venetians made artificial glass eyes in the 16th century.

Modern day optical prosthetics can be traced back to 1832 when Ludwig Muller-Uri produced the first real glass eye in Germany. Today, eyes are made from cryolite — a special glass used specifically for glass eyes with little application in any other area.

To fit a prosthetic, the eye must be sized to the individual. The eyes are made by first lamp-working ⌄ a tube of glass into a ball that has a nipple with which to hold and rotate the glass. Next, the ball is heated and worked down into a flatter, longer shape on to which the blood vessels are placed. The top of the ball around the iris is then blown up slightly to resemble a small mushroom shape. Then the sides of the ball are heated and gently sucked in to give the exact measurements and shape of the finished eye.

There are two types of glass eye — one is a hollow half-formed eye and the other is a thin bowl shape. Their use is dependent on the condition of the socket. These extraordinarily realistic looking eyes offer a very close match to the colouring, depth and surface that you would expect from a real eye. They are testament to the craftsmanship involved in fitting and replicating these uniquely individual body parts.

 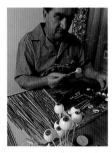 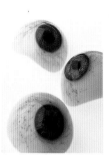

Material Properties	Biologically inert
	Neutral appearance
	Good scratch resistance
	Hydroscopic, retains natural eye fluids (plastic is not)
Further Information	www.ocularist.org
	users.esc.net.au/~paul/eyes.html
	www.kunstauge.ch
	www.augenprothetik-lauscha.de

Prosthetic Eye
Designer: Rainer Spehl
First available: 1999

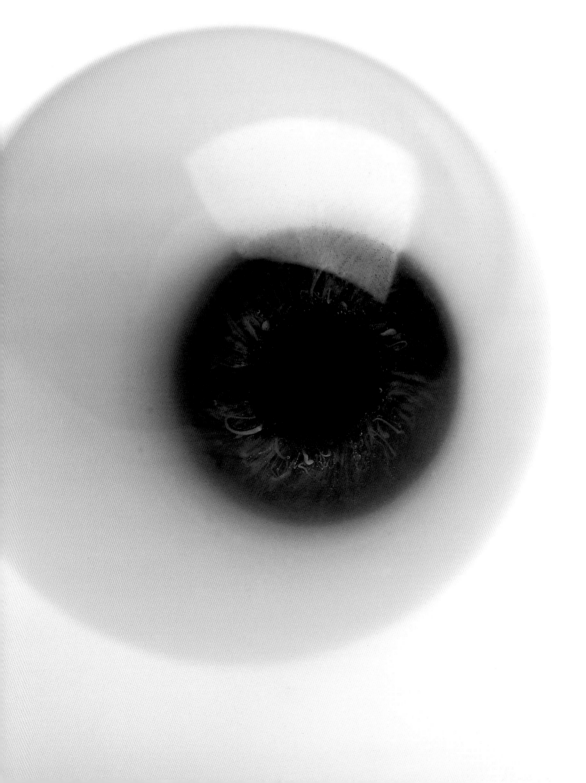

more: Lampworking 016, 038, 044, 063, 076

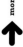

Sweet revolution

Portuguese design group, Proto, continually bring a range of projects that deal with specific materials and ideas to the international design arena. As with many of their ranges, these products require low investment in tooling because as they state, 'we are investing in creativity not complexity'.

These handblown ⌄ soda-lime ⌄ tableware pieces — the Sweet Revolution range — were made in one of Portugal's oldest glass factories, the Marina Grande, which has been producing glass for about 250 years. The name Marina Grande is taken from the region where the factory is based which is also known for its social and political activities. The glassblowers of the Marina Grande factory were an anarchic group pushing for social change. The name of this collection pays homage to these glassblowers and refers to the changes that occurred in Portugal in 1974 when the country was freed from dictatorship.

These pieces are handblown into wooden moulds ⌄. With this level of production the glassblower can easily change and adapt shapes, the thickness of glass and the internal shape of the containers. Production quantities vary from one-off pieces with wooden moulds to several hundred or even thousands with alternative materials.

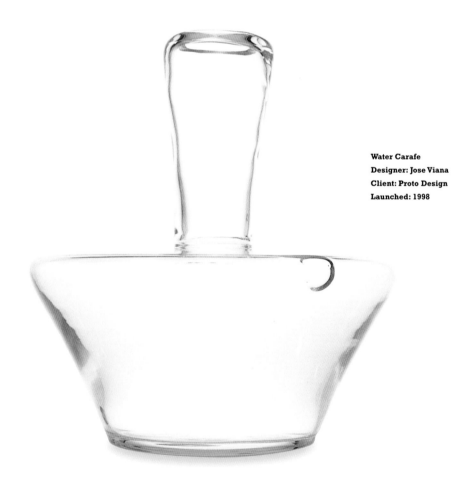

Water Carafe
Designer: Jose Viana
Client: Proto Design
Launched: 1998

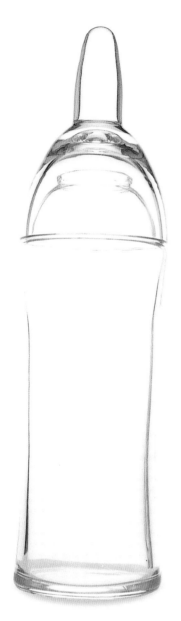

Dimensions	**Water Carafe (1): 190 x 190 x 220mm**
	Wine Decanter: 160 x 160 x 250mm
	Water Carafe (2): 70 x 70 x 290mm
Material Properties	**Low tooling investment**
	Unit costs are high due to high labour costs
	Flexible production process
	Glass can be re-used or recycled
	Soda-lime is one of the softer types of glass
Further Information	**marco.ss@clix.pt**
Typical Uses	**Drinking glasses; vases; bowls; decorative pieces**

Water Carafe
Designer: Paulo Parra
Client: Proto Design
Launched: 1998

Wine Decanter
Designer: Marco Sousa Santos
Client: Proto Design
Launched: 1998

more: Handblown glass 051–053, 056–057; Soda-lime glass 016, 023, 052, 055, 061, 068, 074, 076; Moulds 015, 018, 026, 033, 036, 049, 051, 054–055

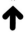

048

Thin and tough

Dimensions	145 x 280 x 168mm
Material Properties	**Good resistance to thermal shock**
	Can withstand high temperatures
	Good resistance to chemical corrosion
	Very low coefficient of expansion
	Excellent resistance to physical shock
Further Information	**www.schott.de/english/jena/hwg**

Teapot
Designer: Wilhelm Wagenfeld
Manufacturer: Schott Jena Glass
Designed: 1931

Ever wondered why you can pour boiling water into some glass cups without the glass breaking? The answer lies in borosilicate glass ↘ which has been used for domestic kitchen products since the early part of the 20th century. Jena Glass produce a range of products exploiting this hard, heat-resistant glass.

This teapot (part of a tea service) was designed by Wilhelm Wagenfeld for Jena Glass in the 1930s as part of an experiment where artists were invited to design products as an alternative to the scientists previously employed to do the job.

The classic tea service design exploits the strong physical properties of borosilicate glass to create beautifully thin-walled, tough products with a strong resistance to sharp temperature changes. Apart from the internal cartridge, each piece is handblown into moulds ↘, including the flat saucers which are produced by blowing a large bubble into a mould which is then scalped close to the base and the edges fire-polished. Spouts and handles are added later.

The refined and precious forms of Wagenfeld's tea service are of a totally different quality compared with pressed borosilicate glass. This range is an early example of a manufacturer replacing technicians with designers to create products – in this case resulting in delicate, skeletal forms, that make full use of the material's basic elements.

more: Borosilicate glass 016, 052, 063–064, 067, 069, 074, 076–077, 105, 132; Moulds 015, 018, 026, 033, 036, 046, 051, 054–055

This concept project looks at the rituals of drinking wine and the production of stemware. The aim was to design a product that was less about a form and more about an observation on the production of a drinking glass.

The idea to produce a wine and water glass as one object was based on a brief given by an Italian tableware manufacturer. Many radical solutions were explored, most based on multiple containers joined together to hold the two liquids. However, the simple production detail of thin wine glasses and thicker water glasses was used as a starting point. This subtle detail of having one side thin and one side thick was all that was needed to create this distinction of drinks.

Two methods were explored in the production of this glass. The first involved handblowing ⇘ a gob with an uneven bubble into a plaster mould ⇘. The second method was to blow the glass without a mould and apply additional heat to one side of the gob, making that side thinner and then forming the shape of the glass by hand.

The thin glassware generally used in the production of wine glasses offers a refined quality and is generally more expensive. The lead crystal ⇘ Thick and Thin Wine Glass exploits this production detail resulting in a design that doesn't shout but instead reveals itself slowly to the user.

Thick and thin

Dimensions	100 x 75mm
Production	Handblown, cut and ground
Material Properties	Low tooling costs
	Moulds can be made for wood, graphite or steel
	Low- to medium-scale production volumes
	Small alterations can be made to each unit
	High unit cost
Typical Uses	Low volume handmade pieces; jewellery; vases; bowls

Thick and Thin Wine Glass
Client: Concept project
Designer: Chris Lefteri
Launched: 1994

more: Handblown glass 046–047, 052–053, 056–057; Moulds 015, 018, 026, 033, 036, 046, 049, 054–055; Lead crystal 074

Lead-free

Hollow ware is one of the most widely used forms of glass. The term describes a range of glass production methods, from handblown ⬎ to pressed ⬎ and machine-made glass, and a huge range of products, from glass packaging to drinking glasses. Hollow ware can be made from many types of glass including borosilicate ⬎, lead crystal ⬎ and soda-lime ⬎.

Finnish glass producer Iittala has a long tradition of design-led domestic hollow ware, and boasts some of the most famous pieces of glass tableware design. Coming to prominence in 1946 when star designers Tapio Wirkkala and Kaj Franck were hired, this Finnish glassblowing company has built a reputation for glass classics using some of the most recognised designers, including Alvar Alto, Marc Newson and Harri Koskinen. A contemporary example is the Relations Series, which keeps this tradition alive by inviting major figures in contemporary design to re-examine domestic lifestyles and re-interpret a range of glass objects.

more: Handblown glass 046–047, 051, 056–057; Pressed glassware 036, 123; Borosilicate glass 016, 049, 062–063, 067, 069, 074, 076–077, 105, 132

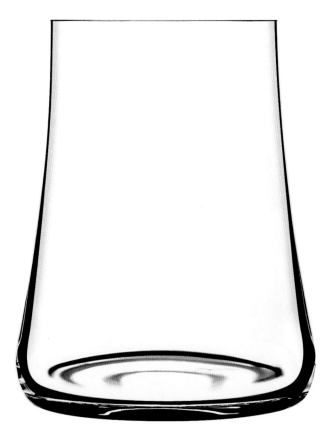

Dimensions	**60cm height x 16–18cm diameter**
Material Properties	**Low tooling investment**
	High labour costs mean expensive unit costs
	Flexible production process
	Glass can be re-used and recycled
Further Information	**www.harrikoskinen.com**
	www.iittala.fi
	www.marc-newson.com

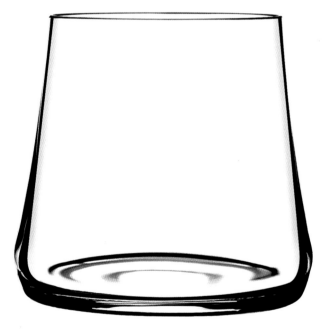

Glasses
Designer: Marc Newson
Client: Iittala
Launched: 2000

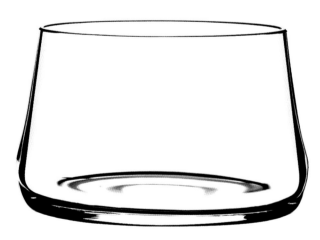

↑ **more: Lead crystal 050, 074–075; Soda-lime glass 016, 023, 046, 055, 061, 068, 074, 076**

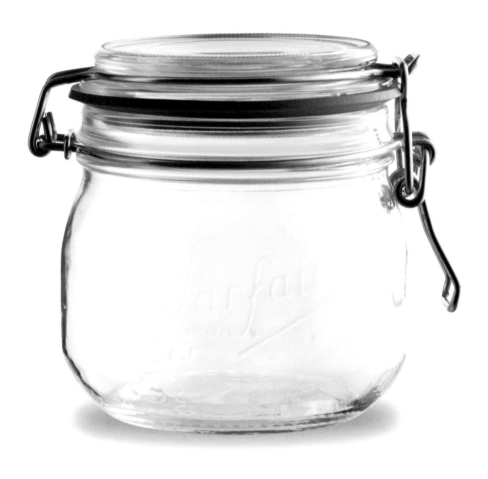

We are talking mass production with a capital M here. Most wide-necked glass jars you find in the supermarket start life as a large mound of sand outside an even larger glass factory. Inside the factories machines shoot out glowing, molten gobs of glass that look like shafts of light as they fall into the blank moulds ⬊. This process lacks the theatre and craftsmanship of batch-made glass. However, the automated, greasy, noisy, steaming machines can produce over 900,000 small bottles per day.

This high-volume manufacturing process is similar to the blow and blow process. The main difference is in the forming of the parison, which, instead of being blown, is pressed around the mould. This increases the production cycle and allows for greater control in the distribution of glass – thus a thinner wall can be achieved. Once formed, the bottles are slowly cooled down to room temperature, which eliminates any tension in the glass.

This process can churn out 400,000 jam jar-sized units per day. And for small press and blow bottles, pharmaceutical bottles for example, these 24-hour machines can pump out up to 900,000 units per day.

The Press and Blow Process

 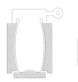

1. Gob dropped into blank mould 2. Plunger presses blank shape 3. Blank pressed 4. Blank shape 5. Blank transferred to blow mould 6. Final shape blown 7. Finished jar

more: Moulds 015, 018, 026, 033, 036, 046, 049, 051, 055

900,000 units per day

Material Properties	Chemically inert; Does not impart taste
	Recyclable
	Uses recycled material
	Good resistance to mechanical shock
	Can be sterilised at high temperatures
	Extremely low unit costs
	High tooling costs
Further Information	www.vetreriebrunni.com
	www.beatsonclark.co.uk
Typical Uses	All mass-produced glass containers

The blow and blow process is typically used for bottles with small necks, such as most drinks bottles. The blow and blow and press and blow processes use the same machines for production, but require different moulds ↘. Both processes usually use standard soda-lime ↘ resulting in 70% of the final bottle being sand. However, most bottles can contain up to 60% recycled glass ↘. Apart from silica, the other main constituents of most mass produced glass containers are sodium carbonate, which helps the vitrifying process, and calcium, which adds stability. Small amounts of magnesium and aluminium oxide are added for waterproofing.

To form the bottles, this mix is emptied into a special two-part furnace containing a main melting basin and a smaller forming basin. After being refined at a temperature of 1550°C the glass is delivered to the forming machines. Here the elongated glass gobs fall into the blank parison mould where they are blown from underneath. This is then flipped 180°C and blown from the top to form the finished bottle.

To achieve the unit price of between 0.11 cents and 1 Euro, a minimum production run of 50,000 is needed to justify the large tooling costs. It is not uncommon for factories to produce the same bottle 24/7 for months at a time.

The Blow and Blow Process

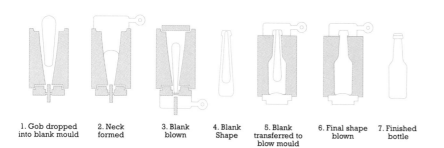

1. Gob dropped into blank mould 2. Neck formed 3. Blank blown 4. Blank Shape 5. Blank transferred to blow mould 6. Final shape blown 7. Finished bottle

200,000 units per day

more: Moulds 015, 018, 026, 033, 036, 046, 049, 051, 054; Soda-lime glass 016, 023, 046, 052, 061, 068, 074, 076; Recycled glass 025

056

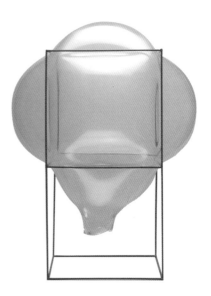

Glass object
Designer: Gijs Bakker
Client: NV Vereenigde
Glasfabrieken Leerdam
Date: 1978

Taking shape

Dimensions	Glass object: 560 x 400mm
	Glass Lamp: 320 x 170mm
Material Properties	Low tooling investment
	High labour costs mean expensive unit costs
	Flexible production process
	Glass can be re-used and recycled
Further Information	www.vetreriebrunni.com
Typical Uses	Low-volume handmade pieces: tableware;
	lighting; studio art glass

These glass pieces possibly say more about the manufacturing process of blown glass than any other examples in this book. The visual qualities of the material take a back seat in comparison to the production process.

The basic process of blowing glass into a hollow mould is the same for batch-produced studio glass as it is for mass produced high volume glass. However, there are many technical restrictions placed upon this technique when applied to the production line and handblown ⌝ glass offers far more room for creativity.

These pieces are part of a commission to design a useful glass object. The steel wire frame clearly demonstrates that the glass will take the form of whatever it is restrained with. This is 'a shape which grows by itself', a free-thinking experiment which produces objects of pure beauty using an organic process.

This curious, anatomical-looking object hides its true function — that of holding a lightbulb without the need for any other fixings. It explores the elasticity of glass in its heated state and the ability of the glassworker to produce forms by pushing and probing.

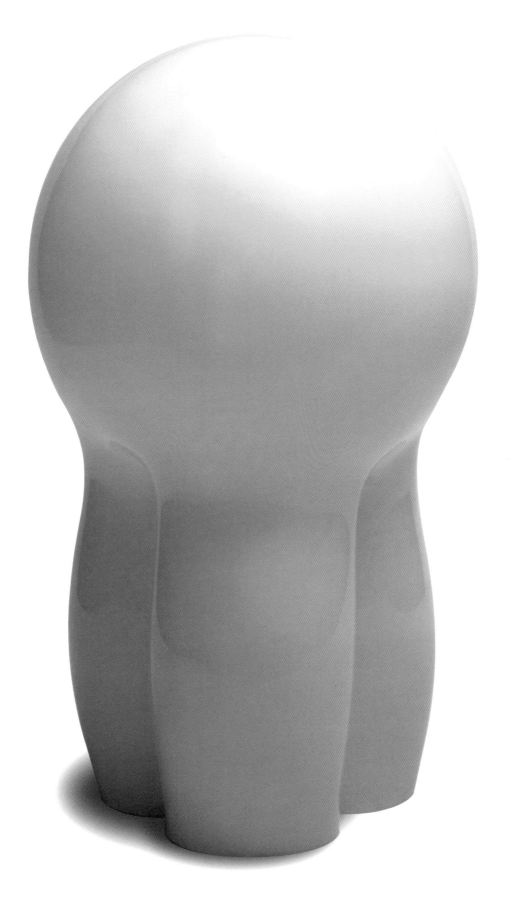

Glass Lamp
Designer: Gijs Bakker
Client: NV Vereenigde
Glasfabrieken Leerdam
Date: 1978

more: Handblown glass 046—047, 051—053

059 Stock

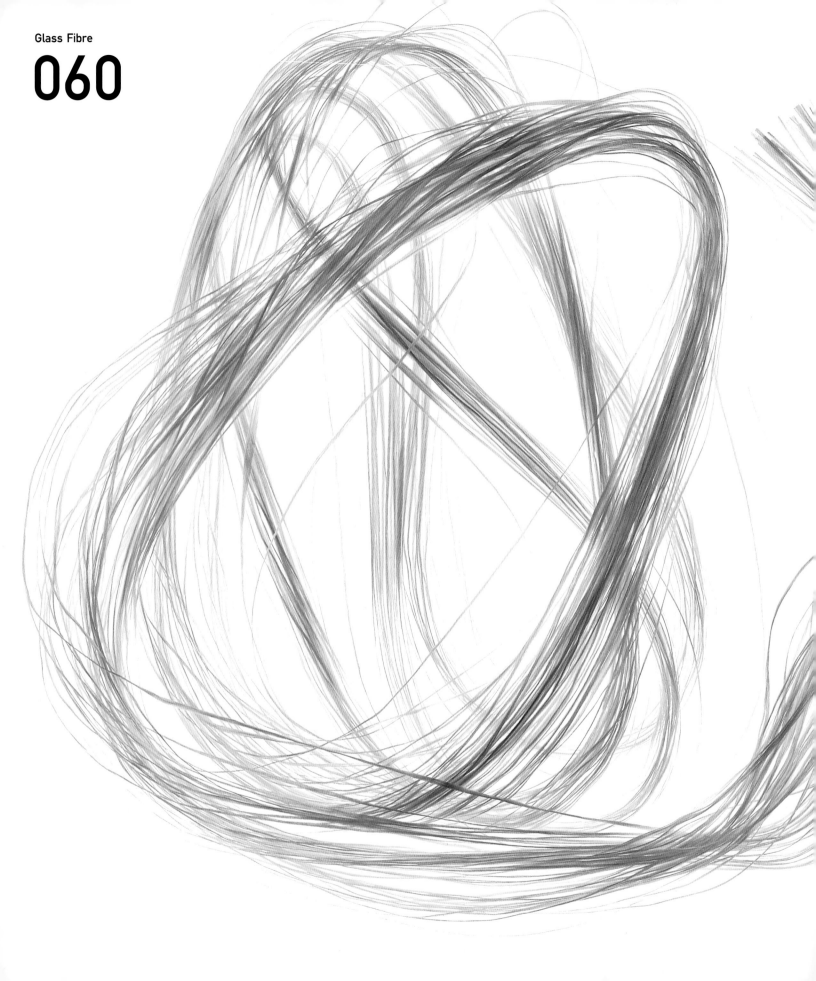

Delicate threads

The true value of glass can only be fully appreciated when considering the number of forms and functions that it assumes, not just on a visual, decorative level but on microscopic and structural levels too.

Glass fibre ⬎ is the collective term for glass that has been processed into thin strands. These can be divided into three product areas: glass wool ⬎ or insulating glass ⬎, textile fibres and optical fibres ⬎. Each one fulfils diverse and distinct functions within a range of industries.

Glass wool is made from soda-lime glass ⬎ by the centrifugal spinning of molten glass beads into short threads and is generally used in building and loft insulation, either alone or combined with mortar or plaster. Fibreglass textiles are used in plastic reinforcement, both in injection mouldings and hand lay-up work and fibre optics are used within a range of industries to carry light. Because optical fibres can transmit light around corners it can be applied within a diverse range of industries.

Dimensions	Diameter can be accurately controlled to the thickness of a human hair
Material Properties	Heat and fire resistant
	Good electrical insulation
	Good strength to weight ratio
	Impervious to many caustics
Further Information	www.corning.com; www.schott.com
	www.cem-fil.com; www.vetrotexeurope.com
	www.saint-gobain-technical-fabrics.com
Typical Uses	Glass-reinforced plastic; boat hulls; automobile bodies; concrete glass yarn for textiles

more: Glass fibres 064–066, 069; Glass wool 064; Insulating glass 125; Optical fibres 064, 082; Soda-lime glass 016, 023, 046, 052, 055, 068, 074, 076

062

Woven rods

Material Properties	**Good resistance to thermal shock**
	Large availability of companies to post form into a range of products
Further Information	**www.zanotta.it**
	www.schott.com

'It's some time that I am intrigued (or interwoven) by the theme of weave. It derives from the use of frail materials creating a very strong structure.' Since the 1950s the Italian furniture producer Zanotta have continually pushed and experimented with domestic furniture design, exploring projects with key figures in Italian design. This unique tray made of glass rods ⬎ set in an aluminium frame continues this tradition.

The surface is constructed from a series of straight and bent borosilicate glass ⬎ rods without the need for adhesives. The use of transparent glass and the open weave structure offers a highly original decorative and structural surface.

Izzika Tray
Designer: Andrea Branzi
Launch date: 1999

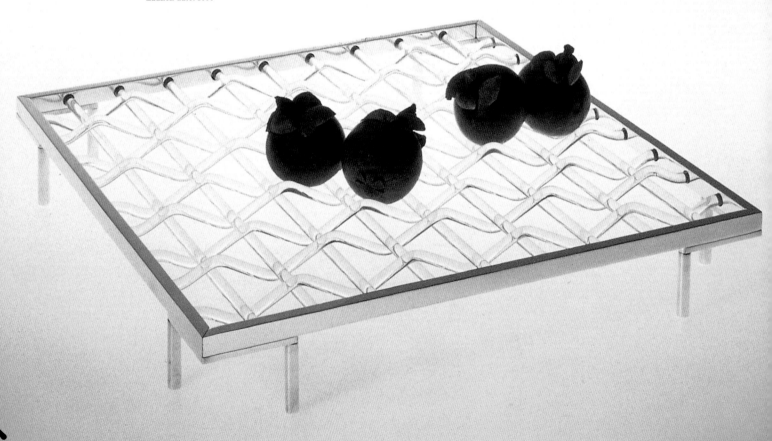

more: Glass rods 020, 033; Borosilicate glass 016, 049, 052, 063, 067, 069, 074, 076–077, 132

Glass tubing is used as a starting point for many products, from domestic tableware and ornaments to ampoules and fluorescent light tubes. Using mainly lampworking ⬎, or bench- and lathe-working ⬎ as two of the processes to form products, they themselves are produced by two main methods: the Danner and Vello processes.

As a semi-finished product, the glass tube is one of the main forms in which glass is bought before undergoing a secondary production process. It is available in round sections as well as an assortment of different shapes. Conturax® by Schott is a range of borosilicate ⬎ inner- and outer-profiled glass tubing that can be worked into a range of products requiring a strong decorative element.

By starting with a semi-finished material the possibilities for creating small- to medium-volume production becomes an option. There are many small to large lathe-working companies that can handform the tube into products avoiding tooling costs.

Dimensions	**Tubes: 1–450mm diameter**
Material Properties	**Good resistance to thermal shock**
	Good workability; Resistance to corrosion
Further Information	**www.schott.com; www.intracel.co.uk**
	www.accu-glass.com
Typical Uses	**Fluorescent lighting; television tubes; scientific equipment; domestic oil and vinegar containers; thermometers; decorative ornaments**

Detail of Conturax® glass tubes by Schott

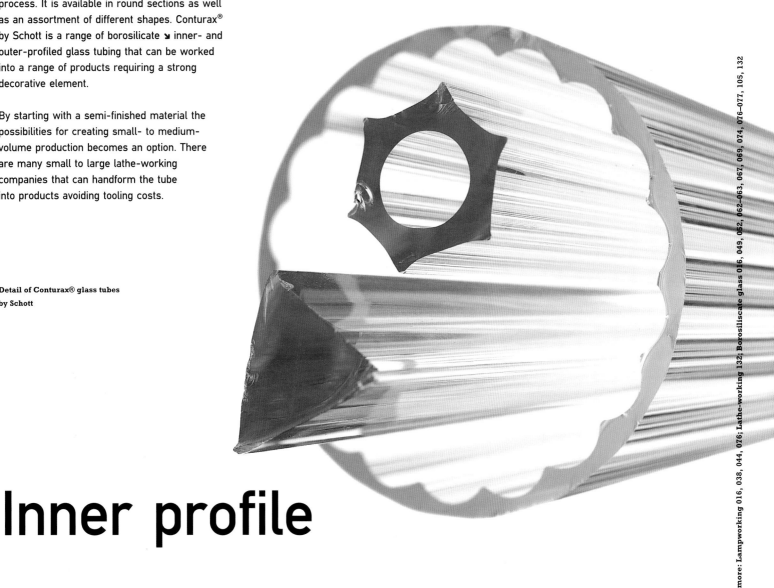

Inner profile

more: Lampworking 016, 038, 044, 076; Lathe-working 132; Borosiliscate glass 016, 049, 052, 062–063, 067, 069, 074, 076–077, 105, 132

064

Glass balloons, fibres ⬎, strands, wool ⬎, flakes ⬎ and spheres are often combined with other materials to improve characteristics. Glass fibre has many applications within both high- and low-tech industries: optical fibres ⬎, glass wool and reinforcements for polymers for example.

The continuous glass fibre in Aldo Bakker's chair is common in furniture design. It is combined with a polymer resin to provide an easily workable material. This glass fibre chair was the result of an experiment using single flowing lines to define a form. The designer has used the transparent qualities of the clear resin and glass fibres to produce a piece that exploits the visual qualities of this form of glass. The chair is constructed from two moulds and cut-out flat patterns of fibre built up into nine layers. Alumino-silicate ⬎ glass is generally used for this type of fibre due to its chemical resistance and high softening point. The glass fibre in this chair is a necessary structural element as well as a decorative one.

Dimensions	810 x 460mm
	Average thickness:10mm
Material Properties	Heat and fire resistant; Good electrical insulation
	Flexible when being worked rigid when combined with resin
	Low cost tooling; Flexible production methods
	Extremely durable; Good strength to weight ratio
Further Information	www.fibreglass.com
	www.globalcomposites.com
Typical Uses	Boat hulls; automobile bodies; protective helmets; furniture; civil engineering; aeronautics; rail transport; architecture; toys

Flexible glass

Glass Fibre Chair
Client: Self-initiated project
Designer: Aldo Bakker
Launched: 2001

066

Pockets of air

Dimensions	**Sold on three criteria: density, collapse pressure and physical size from 15 to 120 microns**
Material Properties	**Lightweight; High strength; Free-flowing; Inert Good thermal insulation properties**
Further Information	**www.3m.com/microspheres**
	www.pottersbeads.com; www.fillite.com
	www.decogem.com
Typical Uses	**Civil explosives; acoustic windows in submarines; silicone sealants; underbody coatings for cars; engine component covers; weight reducer and thermal barrier in paint; insulation for oil pipelines; thermal cements**

Like glass spheres, flakes ⬎ and fibres ⬎, glass beads ⬎ are used as an additive within a wide range of industries and applications, from reducing weight in aircraft paint and explosives to a thermal insulator in domestic paint. One of the early applications was to civil explosives. But it is the combination of its resistance to chemicals, its durability and its ability to be formed into simple shapes which means it can be exploited in a whole range of applications.

As with so many materials, the production of these micro-spheres is one of their most interesting aspects. The raw material starts off at the top of a tower. Droplets then fall past a series of flames, being heated and expanded in the process. This free-falling results in the formation of perfectly round beads. The computer-controlled process is 100% efficient — every glass bubble being collected and packed at the base of the tower. Micro-spheres ⬎ are available in a range of densities — most of which look like a fine powder when seen together.

Illustration of microscopic hollow glass beads

From freezer to oven

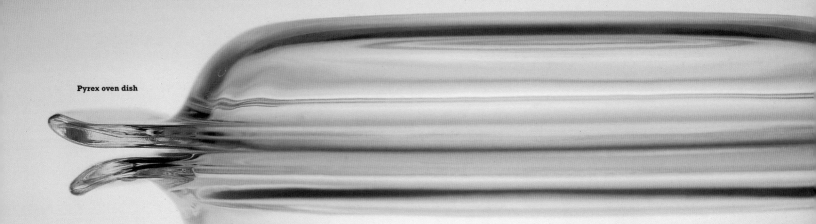

Pyrex oven dish

Material Properties	**Good resistance to thermal shock**
	Can withstand high temperatures
	Good resistance to chemical corrosion
	Very low coefficient of expansion
	Excellent resistance to physical shock
	Can be blown or pressed and sold as flat sheets, tubes or rods
Further Information	**www.worldkitchen.com**
	www.corning.com

This range of bakeware with global fame was first introduced by Corning Glass in 1915. Today it is hard to imagine a new material that could boast as much technology and assurance of a better life as Pyrex did.

Borosilicate glass ↘ was developed in the 1890s by Otto Scott and Ernst Abbe. Corning used the same material to produce lantern glass for the American railways which could withstand the high temperature of the lights and fluctuating weather. But the genuine success of this durable glass was bad for business as it did not need replacing. Corning was then forced to seek out new markets. Bessie Littleton, wife of a Corning scientist, tested this special new glass. She baked a cake in two sawn-off battery jars and discovered several key advantages: cooking time was shorter, the cake did not stick to the sides of the glass and it was evenly cooked.

more: Borosilicate glass: 016, 049, 052, 062–063, 069, 074, 076–077, 105, 132

068

more: Glass micro-spheres 066; Soda-lime glass 016, 023, 046, 052, 055, 061, 074, 076; Alumino-silicate glass 064, 072, 074, 084; Glass beads 066, 071, 135; Road-markings 071, 135

Unexpected

Most glass is processed into products where this hard, transparent, reflective material is at least visible, and often visually exploited in packaging, tableware and glazing for example. However, these same properties give it a unique purpose on a microscopic scale when combined with other materials.

Glass spheres ⬂ from microscopic (10 times the thinness of a human hair) to 1mm-glass balls, are used in both solid and hollow glass varieties within a range of industrial applications. These spheres range from a fine dust to granules that look like grains of salt.

Made from a number of different glass types including soda-lime ⬂ and alumino-silicate ⬂, these hard, perfectly round glass beads ⬂ are a natural choice for road markings as they add reflectivity, as well as being hardwearing. They improve mould shrinkage, warping and increase viscosity within plastic-moulded parts.

Dimensions	75–850 microns
Material Properties	Reflective; Good chemical resistance
	Available in a range of sizes and shapes
	Spherical; High thermal resistance
	Chemically inert
	Easily processed in plastic forming machines
Further Information	www.pottersbeads.com; www.fillite.com
	www.decogem.com
Typical Uses	Reflective road markings; fillers in plastics; alternative to metals for sandblasting, deburring, peening, surface effects

Glass beads

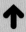

Microscopic

Ultra-thin and powdery, glass flakes ⬎ were originally designed to be combined with other materials to reinforce and strengthen on a structural and microscopic level.

The flat C-type borosilicate glass ⬎ flakes are inert and can be very, very small. One of the main industrial applications is as a barrier coating for pipes. The flat glass flakes bond to produce a layer which, on a microscopic level, acts as an impenetrable blanket. This layering potential is also used to increase the stiffness in plastic mouldings.

Because there is no set shape or direction to the flakes, they offer more support than strands of glass fibres ⬎, which tend to be long, thin and uni-directional. However, when combined with glass fibres they can give even greater strength, toughness and stiffness than could be obtained by using fibres or flakes alone.

Like glass spheres, glass flakes are another invisible form of glass where the structural properties fulfil a function when combined with a secondary material. However, its use on this microscopic level is not just restricted to functional applications – the UK-based company GlassFlake are introducing flakes for use as a decorative surface effect.

Glass flakes

Dimensions	Available from GlassFlake in three thicknesses: 3.5–5.5 microns; 1.9–2.5 microns; 1.4–1.9 microns
Material Properties	Chemically inert; Increases chemical resistance
	Improves wear and abrasion
	Reduces moisture vapour transmission
	Decorative possibilities; Improves fire retardancy
	Improves dimensional stability
	Can lower costs of parts by reducing the amount of resin used
Further Information	www.glassflake.com
Typical Uses	As a reinforcement filler to add strength, stability and durability; to increase fire retardancy in plastic mouldings

more: Glass flakes 064, 066, 088; Borosilicate glass 016, 049, 052, 062–063, 067, 074, 076–077, 105, 132; Glass fibres 061, 064–066

Glass really has no boundaries in its applications nor in the products that can be produced from it. It can be as fragile as eggshell and harder than steel. And there are now fabrics which are 54% glass!

This garment from Samsonite incorporates the same glass beads ↘ found in road markings ↘. They are used for the same reason – to reflect light. It is hard to describe how bright these fabrics are. When applied over a large area – for example, a whole jacket – they make the wearer glow like a three-dimensional lightbulb.

However, the raw material is not new. It was developed by 3M as a safety material for outdoor garments needing a high degree of visibility. And with '30,000 glass beads in every cm^2', this fabric reflects light in an astonishing way. This utilitarian, functional urbanwear and focus on new materials takes Samosonite out of the suitcase and on to the clothes rack.

Black Label Range
Designer: Neil Barret
Manufacturer: Samsonite
Launched: 2000

Wearable glass

Material Properties	**Excellent safety advantages**
	Unaffected by temperature variation
	Can be dry cleaned
	Can be hand-cut, die-cut or guillotined
	Available as yarns or fabric
Further Information	**www.3m.com/market/safety**
	/scotch/psp/index.jhtml
Typical Uses	**Reflective clothing; fashion**

more: Glass beads 066, 068, 135; Road markings 068, 135

072

Super glass

Fused silica ⬂ can withstand temperatures of up to 1200°C for short periods and 900°C for a sustained period. This extreme ability makes it very difficult to work and very expensive. Also known as quartz glass or fused quartz, fused silica is one of the highly heat-resistant materials used in the exterior of space shuttles.

Space shuttle windows are a triple-glazed sandwich: the external and middle panes of fused silica glass have alumino-silicate ⬂ internal glazing. The external fused silica layer protects the shuttle from the high temperatures generated on that all important re-entry to earth's atmosphere. The inner layer of alumino-silicate, known as the pressure pane, protects the internal cabin pressure against the vacuum of space. The fused silica middle section serves as a compromise between the pressure and heat requirements.

The 37 windows in 11 different sizes on the Orbiter shuttle are a great case study in advanced applications for special glass, a material that has been used for 7000 years.

Material Properties	Outstanding resistance to thermal shock
	Excellent resistance to high temperatures
	Good chemical resistance
	Ultra-low expansion
Further Information	www.quartz-silica.com
	www.schott.com
Typical Uses	Space shuttle windows; furnace sight glasses;
	mirror blanks or astronomical telescopes;
	high-energy lasers

Space Shuttle
Image courtesy of NASA

more: Fused silica 072; Alumino-silicate glass 064, 068, 074, 084

To float

Developed in 1952 by Sir Alastair Pilkington, the float glass ↘ technique has remained the key process within Pilkington Glass. The journey begins with the glass being heated and held at a temperature of about 1000°C before it is fed and floated into a long bath of molten tin. A ribbon (a continuous strip of glass) is formed which cools as it flows down the long bath, eventually reaching 600°C. The glass is then fed through a series of rollers until it exits at 200°C. From here the glass is cut into sheets and packaged.

Float glass production has virtually replaced plate glass which required several stages of processing to produce flat sheets.

Dimensions	Thicknesses between 2–25mm
	Standard sheet size is 3210 x 6000mm
Material Properties	Flat surface; Free from distortion
	Can be toughened or laminated
	Suitable for acid etching, bevelling and screen printing; Can be silvered for mirrors
Further Information	www.pilkington.com
Typical Uses	As a base for mirrors; sealed double and triple glazing; base material for laminated glass within transport and buildings, furniture; electronic equipment

Production of
float glass

more: Float glass 026, 103, 110, 136

074

more: Soda-lime glass 016, 023, 046, 052, 055, 061, 068, 076; Borosilicate glass 016, 049, 052, 062–063, 067, 069, 076–077, 105, 132

Rings like a bell

There are three categories of glass that have mainstream general use: soda-lime ↘, borosilicate ↘ and lead glass ↘. There are of course other more specialist glasses like fused silica ↘ and alumino-silicate ↘, but these account for a relatively small percentage of production.

Lead glass, also known as lead crystal or lead alkali glass, is considered the bone china of glass for luxury tableware. Its high percentage of lead oxide (at least 24%), which replaces the lime, goes some way to giving this type of glass a sparkling crystal brilliance that could not be achieved with soda-lime. The most blatant display of this clarity is exploited by cutting, which is why so much cut glass is lead crystal, as well as it being easy to cut.

But lead glass is not limited to fine crystal; glass containing 65% lead oxide is used in applications that require radiation shielding.

Material Properties	High refractive index which means high clarity
	More expensive than soda-lime
	Excellent electrical insulating properties
	Relatively soft
Further Information	www.nambe.com
	www.karimrashid.com
Typical Uses	Drinking glasses; vases; cut glass decorative tableware and ashtrays; stems and bases for lamps and television tubes

Crystal Champagne Glass
Designer: Karim Rashid
Client: Ritzenhoff Cristal
Launched: 1999

more: Lead glass 051; Fused silica 072; Alumino-silicate glass 064, 068, 072, 084

076

Thermal shock

Borosilicate ↘ is one of the wonder glass types. Developed in the 1890s by Otto Scott and Ernst Abbe, borosilicate glass was soon used in street lighting, laboratories, kitchenware, lightbulbs and a whole range of other everyday and special products. It is renowned for its workability and ability to withstand extreme temperature change. Also, the ability to lampwork ↘ this glass meant that objects could be made to specific requirements without the need for tooling.

Today it is still this resistance to sudden temperature change and its ability to withstand chemical corrosion that makes it one of the three major groups of glass types, along with soda-lime and lead. Being about 15% lighter by volume than soda-lime ↘, it has an excellent resistance to physical shock. It has become most recognised under the Corning-developed brandname, Pyrex.

Pyrex Body Jewellery
Produced by: Bodybead

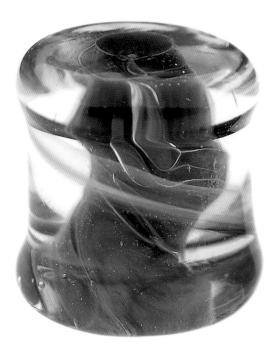

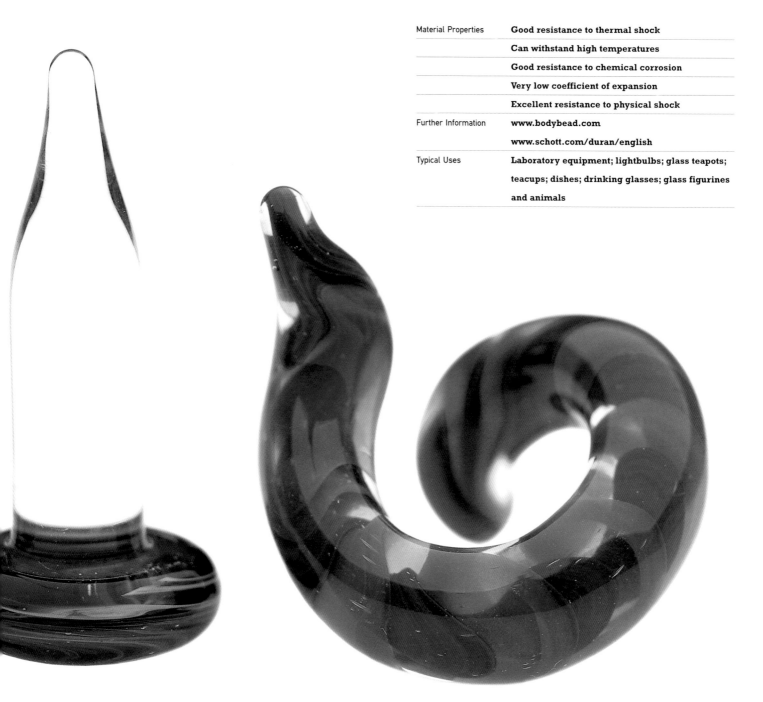

Material Properties	**Good resistance to thermal shock**
	Can withstand high temperatures
	Good resistance to chemical corrosion
	Very low coefficient of expansion
	Excellent resistance to physical shock
Further Information	**www.bodybead.com**
	www.schott.com/duran/english
Typical Uses	**Laboratory equipment; lightbulbs; glass teapots; teacups; dishes; drinking glasses; glass figurines and animals**

more: Borosilicate glass 016, 049, 052, 062–063, 067, 069, 074, 105, 132; Lampworking 016, 038, 044, 063; Soda-lime glass 016, 023, 046, 052, 055, 061, 068, 074

Self-cleaning

This is the kind of material development that makes the national news when it is launched. The most appealing aspect of this self-cleaning glass is that the action of the rain falling on the glass, which you would normally curse after having just cleaned your windows, is the thing that washes the dirt away. Launched in 2001, this non-stick, Teflon version of glass has a coating ⬎ that absorbs ultraviolet light to create a reaction on the surface that breaks down and loosens deposits. When it rains these deposits are simply washed away.

The coating is applied to the glass during the production of the sheets themselves, which means there is no secondary production process. Once windows have been installed, the process of self-cleaning takes several days to take effect as the coating has to absorb enough UV light to begin to work. The principal technology is several years old but it took Pilkington four years to develop it for use on large sheets of glass. These sheets can also be formed for use within the automotive ⬎ industry. Its main advantages are in areas which can be difficult to access, and is most cost-effective in large buildings with reduced cleaning cycles.

Dimensions	Standard sheet sizes: 6000 x 3210mm
Material Properties	Self-cleaning; Leaves no watermarks
	Cost-effective in larger buildings
	Can be single or double glazing
	Does not weaken with age
	Can use with toughened, laminated or bent glass
	Can only be used in exterior applications
	Neutral appearance (comparable to flat glass)
	Can be formed
Further Information	www.activglass.com; www.ritec.co.uk
	ppg.com/gls_aquapel/default.htm
	www.saint-gobain-glass.com
Typical Uses	Architectural glazing; automotive; roofing;
	windows that cannot be opened; conservatories;
	greenhouses; most applications as long as there is
	UV light present

Self-cleaning glass
Produced by: Pilkington Glass

more: Coatings 098, 112, 132–135; Automotive technology 090

081 Techno

082

Glass core, glass skin

Fibre optics ↘ enable light to go round corners, loop and bend, twist and wind. Among the many applications of fibre optics within modern industry, their use in communications has to be one of the most significant. The term 'fibre optics' came about in 1956 and described optical glass drawn into thin long strands which could transmit electrical pulses and light.

In the 1960s the race was on to develop and implement the new fibre optic technology. Physicists, chemists and engineers were all attempting to formulate and produce a type of glass with enough clarity to carry light over an initial distance of one kilometre. In 1970 Corning discovered that two types of glass were needed – a major breakthrough in the field. Fibre optics have a glass core with a silica sleeve. The purity of the core allows for light to pass unobstructed through the length of the cable. The sleeve, which has a lower refractive index, stops any light escaping.

The hair-thin glass fibres were made smaller and lighter than conventional copper and today carry staggering amounts of information – another example of glass being exploited in areas of technology that seem far removed from its more obvious qualities.

Material Properties	Flexible
	Good light-guiding properties
	Not affected by electromagnetic interference
	Chemically inert
	Excellent size to capacity ratio for carrying information
	Generates cold light for medical applications
Further Information	www.corning.com
	www.schott.com/fiberoptics/english
Typical Uses	Medical applications – endoscopes and close precision work for microscopes; display areas where cold light sources are needed; traffic control lighting; decorative domestic lighting

Fibre optics
Produced by: Corning

more: Fibre optics 061, 064

Temperature extremes

Material Properties	High thermal shock resistance
	High mechanical stability
	Low thermal conductivity
	High temperature stability and durability
	Extreme heat resistance; Excellent heat control
	Virtually no thermal expansion
	Translucence for safety
Further Information	www.schott.com/ceran/english/products
	www.corning.com
Typical Uses	Missile nose cones; cooker hobs; cookware;
	windows for coal fires; space telescopes;
	furnace windows

Ceran® Ceramic
Cooker Hob
Produced by: Schott

Originally developed by Schott for use as mirror blanks in astronomical telescopes, glass ceramics have since found applications closer to earth. Probably one of the most common uses is in the familiar black, translucent, flat glass cooking surfaces.

Strictly speaking, glass ceramics are neither glass nor ceramic. The key feature of this unique material is that it does not contain crystals. But by controlling and stimulating growth of crystals it is possible to produce a range of materials with the features of ceramics and glass. The most important physical property of glass ceramics is its ability to withstand extremes of temperature change.

Typically formed from lithium-aluminium-silicate glass, magnesium-aluminium-silicate and aluminium-silicate ↘, glass ceramics have a two-stage manufacturing process. The first involves the right balance of substrates depending on the final end product being melted. The product can then be pressed, blown, rolled or cast and then annealed. Up to this point it is virtually the same as normal glass. During the second phase the moulded products are subjected to a specific temperature and go through a process known as ceramification which means that they reform into a polycrystalline material.

more: Alumino-silicate glass 064, 068, 072, 074

↑

Another smart glass! This material changes from opaque to clear with the flick of a switch — now you see it, now you don't. It can be applied as a divider for both interior and exterior spaces, and has the potential to transform domestic and office environments. This laminated glass �‌↘ is made up of two layers of clear or tinted glass. An interlayer of liquid crystal film is sandwiched between them. Passing an electric current through the film excites the liquid crystals into a state where they align themselves and the glass becomes transparent. When the current is turned off the crystals relax, diffusing light in all directions and making the glass opaque again.

This kind of intelligent glazing ↘ could replace traditional windows, walls and curtains and alter our living and working environments dramatically. Partitions made of this kind of glass allow areas to be changed from private to public and back again with the flick of a switch.

Bombay Sapphire Fishtanks
Heathrow Airport
Installed: January 2001

Vision control

Dimensions	Maximum sheet size: 2800 x 1000mm
	Minimum sheet size: 305 x 405mm
	Standard thicknesses: 11, 12, 14mm
	Based on Saint-Gobains PRIVA-LITE® glass
Material Properties	Instantaneous adjustable vision
	Excellent clarity in transparent state
	Low power consumption
	Can be laminated for security and soundproofing
	Can be curved; Can be used externally
	Versatile forming process
Further Information	www.sggprivalite.com
Typical Uses	Partitioning; doors; security; screens; transport; museum display cases

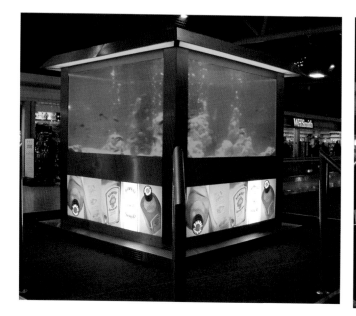

more: Laminated glass 086, 103, 115–118, 128; Glazing 096, 109, 112, 117, 121, 125

086

Old and new

Glas Platz® are in love with technology and in love with glass. Hi-fi designers are always looking to new materials to help reproduce real sound. The special aspect of this company's highly innovative products is the transferring of a material to a new context. It is not so much that a piece of flat, square glass can look so technically and visually stunning — it is more that this piece of hard, transparent, inert material can be used to produce sound.

These loudspeakers have panels of laminated glass ↘ and use flat membrane technology. The essential part of the speaker is the glass panel, which acts as the resonator; this is then covered by the decorative CD.

Glass Sound® Loudspeaker
Designer: Karl-Otto Platz
Producer: Glas Platz®
Launched: 2000

Techno Sound Wall®
Designer: Karl-Otto Platz
Producer: Glas Platz®
Launched: 2000

Dimensions	Glass Sound® Loudspeakers can be tailored
	to customers' requirements
	Techno Sound Wall®:
	339 x 400 x 27mm (without mounting set)
Further Information	www.glas-platz.de
	www.cyberselect.co.uk

more: Laminated glass 085, 103, 115–118, 128 ↑

088

Colour cells
Designed by: Solar Century

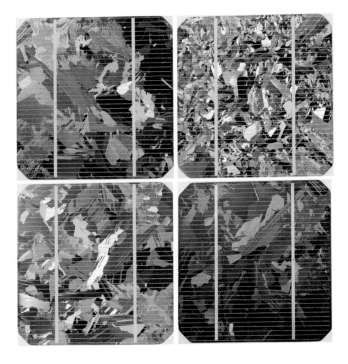

Dimensions	Cells are typically 100–150mm²
Material Properties	Large range of decorative possibilities
	Suitable for structural applications
	Fully compliant with fire safety standards
	Can incorporate a wide range of glass
Further Information	www.solarcentury.co.uk
Typical Uses	Building facades; canopies; shading systems; atriums; louvres; roof tiles

In a single day the sun can generate enough electricity to power the world for several years. The use of solar panels is already widespread as a replacement for constantly diminishing fossil fuels. There are many companies specialising in solar panels, but what makes these products so special is the decorative as well as functional potential they offer.

Solar Century is a UK-based company specialising in photovoltaic technology for applications in domestic and industrial markets. Their products not only offer incredible potential for buildings to harness a renewable energy source but also boast a range of decorative effects. The laminated panels of opaque and semi-transparent finishes can incorporate many colours from metallic silver, bronze and gold to basic red, green and magenta.

The flakes ⬎ are formed from crystals grown using a polycrystalline method. The colour comes from varying the thickness of the anti-reflective coating. Blue, for example, has the thickest anti-reflective coating, which in turn is the most efficient. Silver has the thinnest coating and is the least efficient. These panels can also be used in roofing where the cells act as a shade to reduce solar heat gain.

Astro Power AP-120 modules,
Big Brother House (2001)
solar wall, London
Designed by: Solar Century

Solar Photovoltaic Glass Laminates

089

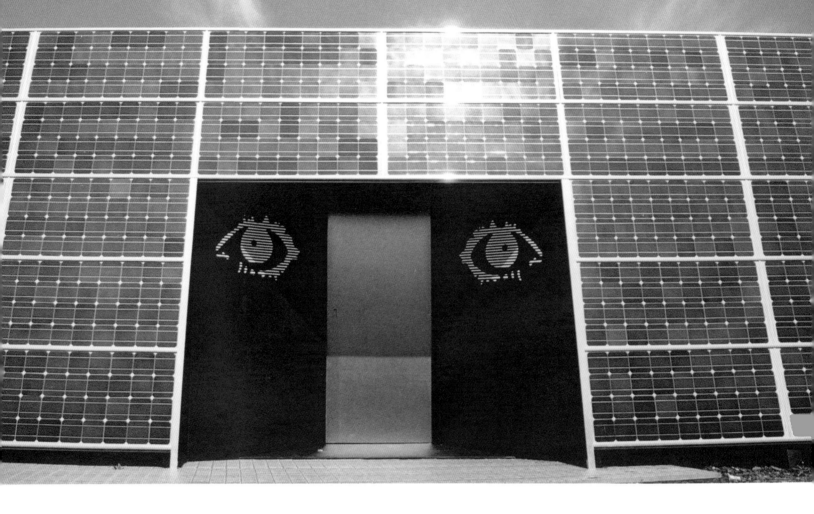

Light and electricity

more: Glass flakes 064, 066, 069

Electrochromic
Rear View Mirror
by Gentex

Further Information	www.electrochromicmirror.com
	www.pilkington.co.uk/about/environ/31_2.htm
	www.glassresource.com
	/sneakpeek/sample4.htm
	www.epfl.ch/icp/ICP-2/electr.html
Typical Uses	Mirrors; windows; screens; partitioning

The intelligent mirror ⬎ is here! For over a thousand years mirrors have quietly performed their decorative and functional tasks. But now electrochromics have opened up new display and sensing applications.

Electrochromics are materials that darken according to the amount of light they receive. In this case they work by employing optical sensing devices to control the transmission of light through glass. Electrochromic glass has found a home in increasingly more sophisticated car interiors ⬎. Gentex are a leading company in this field with a number of applications, from interior automatic dimming rear view mirrors that change from bright to dim, eliminating glare, to an exterior mirror that incorporates an LED turn signal. This technology can also be applied to windows which automatically darken with incoming light. So, with glass giants like Pilkington producing an E-control glass, you may never again need to pull those tangled pieces of cord to adjust your blinds.

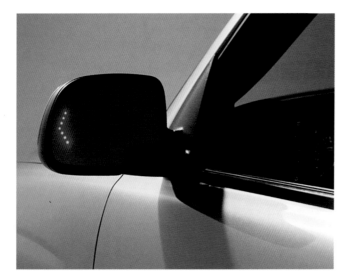

Mirrors of the future

The drive to find new materials which will work in harmony with the body, is a constant factor influencing material and medical research. Professor Larry Hench, with Julia Polak, developed Bioglass® as a result of researching how best to repair the fractured bones of Vietnam veterans. It is not just an artificial, external, cosmetic substance but a material that is engineered to work internally with the body in healing and generating new tissue and bone.

The usual silicone atoms in normal glass hold the atoms in this material together. Bioglass® is only 45% silicone compared with 78% in normal glass. This is replaced by larger amounts of calcium, sodium and phosphorus which make it more attractive to the body's chemicals. Bioglass® works like a fertiliser by assisting in an exchange of molecules when the material comes into contact with body fluids – this then produces a chemical that can physically bond with tissue and bone.

This illustration shows a replacement for a small bone in the middle ear – the part which restores hearing after trauma or infection.

Surface-changing

Dimensions	**Height 5mm; diameter: 1.25–2.5mm**
Material Properties	**Important as a bio-material**
Further Information	**www.usbiomat.com/bioglass**
	www.ic.ac.uk/templates/text_3.asp?P=2780
Typical Uses	**Used around the world in a variety of applications to repair damaged tissue, bones, teeth and joints. It is also being developed as very fine particles for de-sensitising sensitive teeth**

**Bioglass®
Developed by Professor Larry
Hench in collaboration with
Julia Polak
Discovered: 1969**

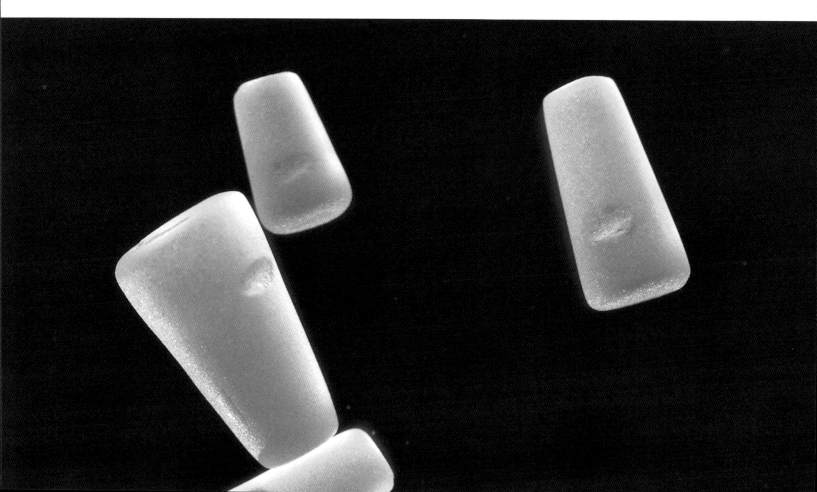

092

From veneered wood to charcoal grey, the television has gone through many external facelifts. But the internal guts of the familiar, everyday television have basically stayed the same, providing probably the richest assortment of glass in one product found in the home.

Cathode-ray tube (CRT) television sets have used the same basic three components since 1955 when the first fully automated production lines were set up. They consist of the neck, a funnel and the front panel. The complexity of CRT televisions requires a number of types of glass to fulfil different functions. Each one is chosen for its thermal properties among others, which enables the various parts to remain sealed in high temperatures.

A special kind of sealing glass is used to connect the metal electrodes which carry high voltages. X-ray absorption must also be considered — alkali-barium-silicate glass is used for the screens which are generally pressed. Lead glass is used for the funnel and neck, which can be pressed or rotation-moulded and absorbs X-ray radiation very well.

The introduction of flat LCD screens may eventually see the demise of CRT televisions but the future of glass in this universal product is still guaranteed.

Material Properties	**Absorbs X-rays**
	See technical table for a breakdown
	of each type of glass
Further Information	**www.schott.com**
	www.corning.com

Television tube
Produced by: Corning

Glass assortment

095 Flat

096

Dimensions	420 x 420mm
Material Properties	Cost-effective
	Holds panels together when broken
	Fire-resistant properties
Further Information	www.glaverbel.com
	www.saint-gobain-glass.com
	www.jhanstanley.co.uk
	Jhan Stanley, London, UK; Tel: +44 (0)207 377 5501
Typical Uses	Doors; windows; overhead glazing; furniture; partitions; fire-resistant panels

With its distinctive mesh and rough, textured surface one cannot escape the suggestions of industry that wire-reinforced glass provokes. However, this sandwich of rolled glass (or cast glass ↘) and embedded wire occupies a unique position within glazing. Its traditional use is in applications where strength and security are of major importance. Its ability to remain in one piece when smashed has a particular use in roofing where objects falling on to the glass do not result in a shower of glass underneath. With the use of rolled glass and its lack of true clarity, this product offers a cost-effective alternative to laminates.

Forming the wired glass sandwich involves a continuous ribbon of molten glass, half the thickness of the final sheet, being squeezed through rollers over which the layer of wire is applied. A second layer of glass is then added to form the sandwich, which is compressed before being annealed. Wired glass is available in a range of patterns and differently-sized mesh.

Taking materials out of their traditional context into different settings is a common theme. Jhan Stanley takes her inspiration from everyday found and discarded objects. She uses paper plates, plastic cups and cutlery for inspiration, and through changing the material finds new contexts for these products.

Security blanket

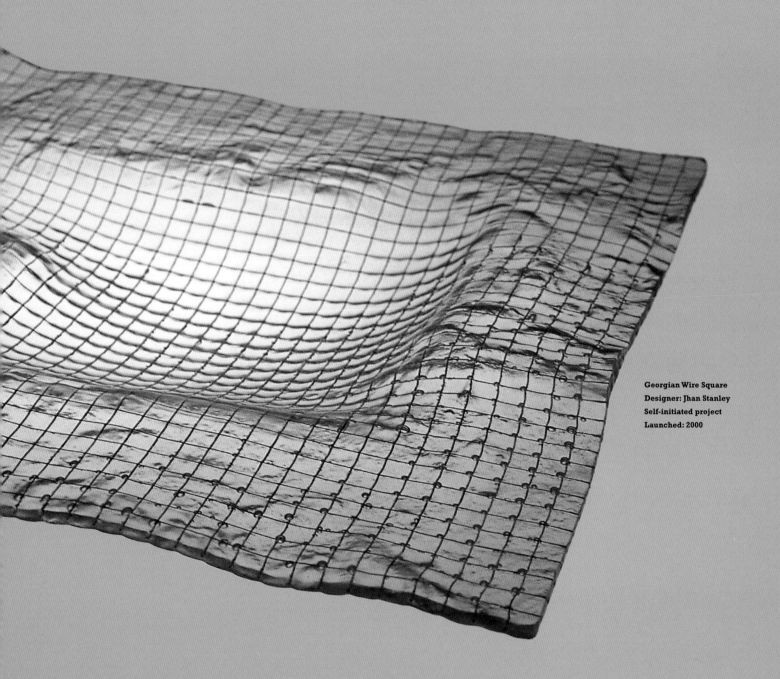

Georgian Wire Square
Designer: Jhan Stanley
Self-initiated project
Launched: 2000

more: Cast glass 018, 023

098

The origin of the glass-backed mirror ⇘ lies in the canals of 16th-century Venice where flat glass was backed with mercury and tin. To make a mirror, a sheet of glass is coated with a stannous chloride solution to prepare it for silvering ⇘. The reflective surface is made up of a blend of silver nitrate, ammonia, caustic soda and distilled water which forms a coating of just 0.01mm. Once dry a protective layer can be applied to protect the mirror surface.

Rebecca Newnham's appreciation of mirrors is built on their ability to not only reflect an image but also to play with light by reflecting it on to interior and exterior surfaces and interacting with the environment. Rebecca designs to commission for interiors and exteriors.

Dimensions	**100cm in diameter**
Further Information	**www.rebeccanewnham.co.uk**
	www.saint-gobain-glass.com
Typical Uses	**Decorative and functional domestic mirrors;**
	mirrors in telescopes; camera lenses; sunglasses

More than reflection

Zen 1 Mirror
Designer: Rebecca Newnham
Launched: 1993

Silvery effects on a flat sheet, with a deceptive depth of colour and texture – these are the light-changing qualities that give Dichrolam™ its special-effect personality. When John Blazy was working with dichroic glass he found that it had certain physical limitations. His desire for a new material made this designer turn chemist to produce Dichrolam™. This unique material is made up of hundreds of layers of polymer sheets sandwiched between two layers of glass. This stack of layers takes incoming white light and separates the colours by reflecting back certain colour wavelengths so that a series of three-dimensional textured patterns can be seen. Dichrolam™ has been used in light panels, which change colour as you walk past, as well as conference tables for MTV.

Dimensions	237cm lengths in 95cm and 117.5cm widths
	Thicknesses: 0.5–2.5cm
Material Properties	Can be fabricated like any laminated glass sheet
	Interior and exterior use
	A fraction of the cost of dichroic glass
	Distinctive 3D pattern
Further Information	www.johnblazy.micronpcweb.com
	www.vitglass.com
Typical Uses	Flooring; partition walls; furniture; lighting; wall tiles; architectural glass panels; table/bar tops; diffractors for light fixtures; shower doors

3D image, 2D surface

Black Sea Dichrolam™ sample
Launched: 1999

100

Think of a traditional British pub window with its combination of ornate sandblasted ⬂ decoration mixed with deep, engraved pattern work. It is this pattern work that is brilliant-cut ⬂. Brilliant-cutting is an old process, with its antique mirror ⬂ and pub window associations, but it is still valid as it provides a unique way of cutting into glass.

There are two main methods used for brilliant-cutting: firstly, hand-cutting, using an upright diamond wheel (allowing for virtually any design) and secondly, machine-cutting, for straight or curved lines. The handmade process is a highly accomplished age-old technique for decorating glass. It is traditionally learnt through an apprenticeship, which can last up to seven years.

Any pattern or design can be cut. It produces a rough, grey, sandblast finish naturally which can be polished up to a smooth surface. Its predominant use on mirrors provides the optimum way to appreciate and bring out the surface detail, which can be less obvious on clear glass.

Deep engraving

Dimensions	Maximum sheet size for handcutting: 4 x 3ft
	Maximum depth of cut: 2mm
Material Properties	Unique decorative appearance
	No tooling
	Good for general detail
Further Information	www.greymcdo.co.uk
	www.glass-design.net
Typical Uses	Doors; cabinets; mirrors; windows

Brilliant-cut glass

more: Sandblasting 023, 025–026, 028, 100, 103, 116; Brilliant-cutting 103; Mirrors 090, 098, 100, 132

more: Float glass 026, 073, 110, 136; Laminated glass 085–086, 115–118, 128; Sandblasting 023, 025–026, 028, 100, 116

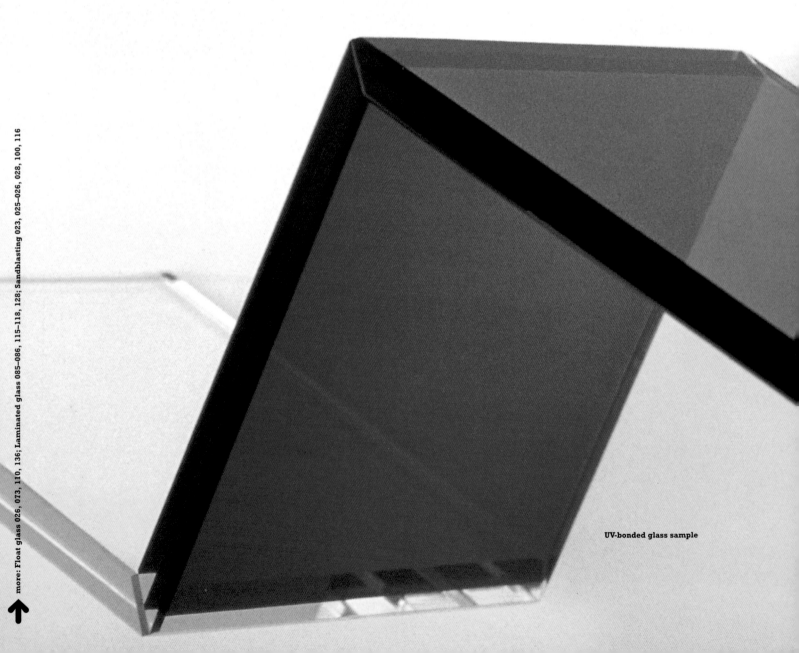

UV-bonded glass sample

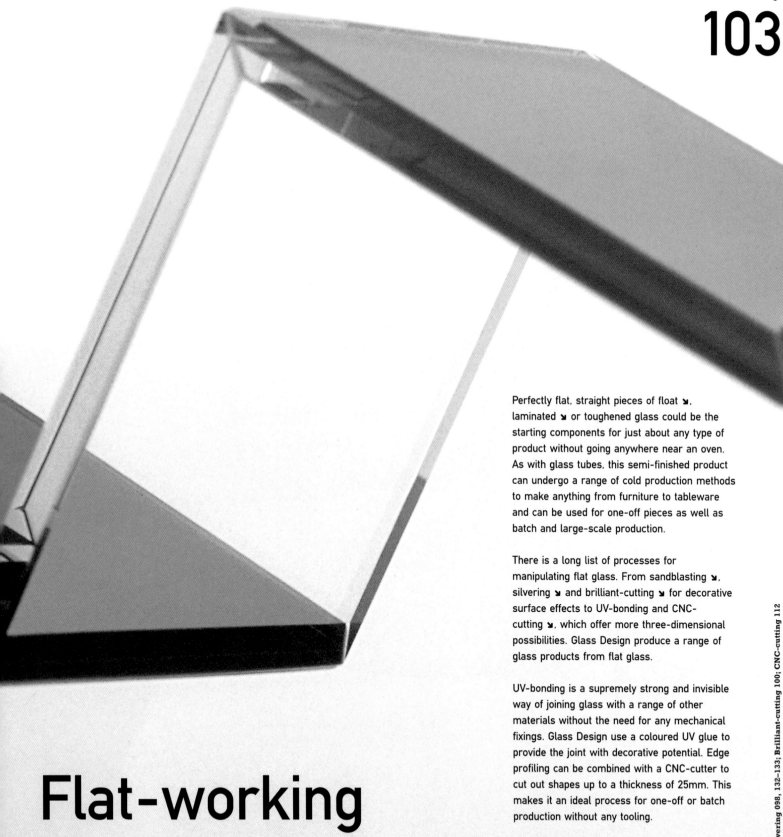

Perfectly flat, straight pieces of float ⬂,
laminated ⬂ or toughened glass could be the
starting components for just about any type of
product without going anywhere near an oven.
As with glass tubes, this semi-finished product
can undergo a range of cold production methods
to make anything from furniture to tableware
and can be used for one-off pieces as well as
batch and large-scale production.

There is a long list of processes for
manipulating flat glass. From sandblasting ⬂,
silvering ⬂ and brilliant-cutting ⬂ for decorative
surface effects to UV-bonding and CNC-
cutting ⬂, which offer more three-dimensional
possibilities. Glass Design produce a range of
glass products from flat glass.

UV-bonding is a supremely strong and invisible
way of joining glass with a range of other
materials without the need for any mechanical
fixings. Glass Design use a coloured UV glue to
provide the joint with decorative potential. Edge
profiling can be combined with a CNC-cutter to
cut out shapes up to a thickness of 25mm. This
makes it an ideal process for one-off or batch
production without any tooling.

more: Silvering 098, 132–133; Brilliant-cutting 100; CNC-cutting 112

Flat-working

Dimensions	AF45, D263 T flat panel display glass in standard sheet sizes of 440 x 360mm
	Alternative sizes can be produced to order
	AF45 0.045–1.1mm; D263 0.03–1.1mm
Material Properties	Extremely thin; Flexible
	Superior flatness; Chemically resistant
	Good surface for coatings
	Good thermal resistance
Further Information	www.schott-displayglas.de
	www.schottglass.co.uk
Typical Uses	Flat TV screens; mobile phones; pagers; PDAs; watches; opto-electronic components; glass wafers for temperature sensors; PALC displays; electronic toys

World's thinnest glass

Extremes are always interesting. Schott is just one of the companies that produce flat panel display glass, and appear to hold the record for the thinnest glass in the world, which measures in at just 0.03mm. This paper-thin glass is so thin that it bends like a plastic film.

Pushing technology in one area has had the knock-on effect of related industries having to push their own boundaries of development. Super-thin flat panel display glass is one example. The increasing miniaturisation of hand-held electronic products requires ultra-thin borosilicate glass ⬎ for greater optical clarity and scratch resistance over polymer alternatives. Schott produce three main types of display glass which are differentiated by their alkaline content and thermal expansion rates.

One of the surprising features of this type of glass is its flexibility which allows it to be formed into curved screens. It is widely used in touch-screen displays.

Sample of flat panel display glass from Schott

more: Borosilicate glass 016, 049, 052, 062–063, 067, 069, 074, 076–077, 132

107 Architectural

Dimensions	Maximum panel size: 3150 x 1750mm
	Maximum thickness: 25mm
	Sheets can be curved; Minimum radius: 1000mm
Material Properties	Can be bent or curved; Handmade process
	One-off or batch-produced
	Low tooling costs for one-off pieces
	Cost-effective compared with other decorative materials
	Can be toughened or laminated to British Standard 6206
Further Information	www.fiamitalia.it; www.ozoneglass.com www.fusionglass.co.uk
Typical Uses	Counter tops; flooring; partitioning; screens; feature windows; stair treads; doors; signage; furniture; sculpture

Transparent rock

The liquid concrete and transparent rock effects produced by kiln-cast glass ➘ offer new possibilities for visual and tactile experiences in architectural detailing. Panels react and reflect light, and distort movement, which can change perceptions of space. By bringing an ancient handmade process into architecture and combining it with modern technology and building techniques, new applications and possibilities for internal decorative and external glazing ➘ come into play.

One of the original inventors of large scale, kiln-formed glass, Ozone Glass was started by Warren Langley and is at the forefront of decorative, architectural glass panels. The process of slumping glass over moulds is not new, but solving the problem of toughening sheets of glass on such a large scale was one solution which Ozone Glass are largely responsible for developing.

Designs can be specified from a large range of standard effects or can be custom designed on flat or curved panels. The casting on the underside of the glass means the top surface has a smooth undulating effect. These chunky surfaces which can incorporate text and logos can be enhanced by using lighting as an integral part of the installation. Lighting creates a range of watery effects that exploit the transparent and translucent qualities of the glass to the full, like looking up at the surface of a clear, blue sea from the sea bed.

Kiln-cast decorative panels
Produced by: Ozone Glass.

more: Kiln-cast glass 026; Glazing 085, 096, 112, 117, 121, 125

Glass and aluminium
panel sample
Produced by: Cellbond
Architectural

Kaleidoscopic

As far as panel products go this kaleidoscopic material has to be one of the most visually interesting. Float glass ↘, aluminium and resin combine to create the hollow honeycomb cells, giving a greater strength to weight ratio than standard glass-only sheet materials.

These honeycomb cells also create a fly's eye view by distorting the light and deforming the world into a series of tiny apertures, giving it a unique aesthetic potential. A range of colours and surface finishes can be specified to enhance this effect or used for more practical applications such as non-slip flooring.

Cellbond Architectural produce composite panels using rigid honeycomb cell structures bonded between a range of materials. These panels exploit the hardness, transparency and scratch resistance of glass within interior and architectural applications to produce a totally unique visual experience. It is the seeing but not recognising that suggests potential for situations where light but also privacy is needed.

more: Float glass 026, 073, 103, 136

Dimensions	Any size to order up to 3000 x 1500mm
	Thickness: 25–50mm
Material Properties	Strong; Lightweight; Rigid
	Range of sizes and thickness
	Available in any colour; Matt or gloss finish
	Highly unique decorative quality
	Available in a range of surfaces
Further Information	www.cellbond.com
Typical Uses	Flooring; stairs; banisters; doors; screening; partitioning; light diffusion; exhibition stands; suspended ceilings

Dimensions	**A4 up to any size; Up to 10cm deep**
Further Information	**Ruth Spaak**
	Glass for Interiors, Stratford-upon-Avon, UK
	Tel: 01789 415244
Typical Uses	**Window features; blinds; screens; room dividers**
	(best seen against a window); interior screening

Materials medley

Ruth Spaak was originally a constructed textile designer, but after re-training in glass she discovered a particular working method which is a unique marriage of the two. She produces a range of pieces, which are literally a fusion ↘ of glass with other materials.

She begins by hand-cutting tiny pieces of glass into squares, circles, and rectangles using a basic glasscutter. This is the most time-consuming part of the process but offers the most rewards. 'The making is like playing; the making up is pure pleasure — that's the best bit.' The hundreds of tiny pieces are laid on a special paper that stops the glass from sticking to the kiln when heated.

Heating and fusing gives each piece a smooth, fire-polished edge. The fused pieces can then be stitched, knotted, and tied together using a range of found objects, from cables to latex rubber. The clear glass is the most important element in each piece, and, when combined with the colour and texture of other materials, gives glittery, harsh and transparent visual effects.

Lace Construction
Designer: Ruth Spaak
Launched: July 2001

more: Fused glass 020, 123

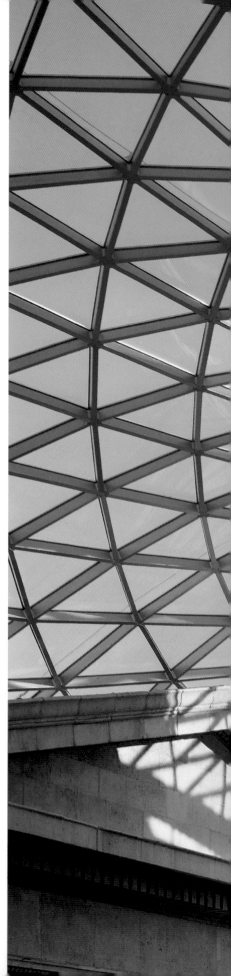

Dimensions	Total thickness: 38.7mm
	Panels vary: 800 x 1500mm and 2200 x 3300mm
Material Properties	Excellent thermal and sound insulation
	Cavities can incorporate secondary materials
	Can incorporate decorative elements
	Available double or triple glazed
	Can be made from clear, body-tinted, annealed, toughened or laminated glass
Further Information	www.daylight.uk.com; www.okalux.de www.fosterandpartners.com
Typical Uses	Sloping and vertical structures; bolted, suspended assemblies

Glass ceiling

There are three main types of double glazing ⬎: mass-produced, low specification windows for domestic and office buildings; architectural glass with special coatings ⬎, and highly specialised applications such as curved glass, or panels with functioning cavities. The glass used in the Great Court fits into the second area. The predominant feature is the glass roof. The minute you walk into this luxurious space you can't help but marvel at the delicate, organic steel lattice grid of the roof structure.

The use of glass in this structure is important due to the processing, logistics and creativity of the project, rather than the type of glass that was specified. Each of the 3312 differently sized, CNC-cut ⬎, Okatherm units has three coatings. The main function of all these coatings is to reduce the solar energy and amount of direct sun penetrating the building, while still letting daylight in — they prevent over 75% of the sun's heat from ever entering the court.

British Museum Great Court
Designer: Norman Foster
and Partners
Client: British Museum
Completed: 2000

Millennium Wheel
(British Airways London Eye)
Designer: Marks Barfield
Architects
Erected: 1999

Dimensions	135m high
Material Properties	Remains in one piece if broken
	Good resistance to physical shock
	Can be bent; Can be printed
	Coloured interlayer can be incorporated
Further Information	www.sunglass.it; www.dupont.com/safetyglass
	www.marksbarfield.com; www.saintgobain.com
	www.dupont.com/safetyglass/lgn/
	stories/1702.html
	www.glavebel.com

Flying windows

On a clear day the 32 capsules of the revolving Millennium Wheel offer breathtaking 360°C views across London and beyond. The most obvious material to use was glass. But how do you produce an aerodynamic capsule that can hold 25 people and also deflect high winds?

Laminated glass ↘ was decided upon because of its strength and ability to remain intact when broken. However, forming a compound curve in laminated glass had not been achieved before. For the 32 capsules, 1152 panes were produced with 11 different shapes and seven types of bending, utilising 14 different moulds. Sunglass developed a process that involved bending three sheets together and then discarding the one next to the mould. For the most severely curved panes (1:4 bend depth), a pinhole enabled vacuum-assisted moulding without overheating.

This important landmark on the London skyline is also home to a highly advanced process of forming laminated glass sheets.

more: Laminated glass 085–086, 103, 116–118, 128

Blue Crack 2
Designer: George Papadopoulos
Launched: 2000

Smashing effects

Dimensions	Maximum size of individual panels 2500 x 1000 mm; Average thickness 15–18mm
Material Properties	Decorative qualities
	Toughened safety glass
	Can also use fire rated glass
	Flexible to suit various regulations
	Bespoke site specific
	Corresponds to BS6206 impact performance in flat glass for buildings
Further Information	www.yorgos.dircon.co.uk
Typical Uses	Screening; flooring; decorative panels; windows; table tops; doors

There is something quite satisfying about deliberately breaking glass. So what a great way to design, smashing glass with a hammer and bricks knowing that no two pieces will ever be the same. Yorgos has turned smashing glass into a creative, organised art form. He smashes to commission for various applications, using the sheet laminating process.

The tools and process of this smashing craft are not quite as basic and obvious as they might seem. To make a typical glass panel, an assortment of hammers, bricks and other hard objects are used to smash and break pieces of coloured or clear glass over a variety of different surfaces.

Depending on the desired effect, specific areas of the panels are then sandblasted ⬎ and polyester pigments are added for colour. A polyester resin is then applied to laminate ⬎ the artwork between two sheets of glass. The final designs play with the transparent layers and unique reflections of light from the cracked and smashed glass.

more: Sandblasting 023, 025–026, 028, 100, 103; Laminated glass 085–086, 103, 115, 117–118, 128

Dimensions	Romag Ltd produce bullet-resistant glass in standard thicknesses from 15–76mm
	Custom glass can be made up to 150mm
Material Properties	Excellent resistance to physical shock
	Can be bent; Can be printed
	Suitable for diamond cutting
	Can incorporate solar control products
	Coloured interlayer can be incorporated
Further Information	www.romag.co.uk
	www.dupont.com/safetyglass
Typical Uses	Military vehicles; government buildings; VIP residences; bank counters; jewellery stores; security for display cases in museums

150mm thick

The idea that glass — which is usually so easily breakable — can stop a bullet, gives security glazing ⬎ (or laminated glass ⬎) the 'wow!' factor. Its forms are many, but security glazing is basically a glass sandwich of two pieces of plate glass joined together with a plastic layer. This plastic layer holds the pieces of glass together if the glass is broken. Together with chemical and thermal tempering, laminating is one of the ways of toughening large areas of sheet glass and making them safe when broken. Unlike toughened glass, drilling and cutting can further process laminated glass.

Romag's range includes bullet-resistant glass and blast-proof glass for use within the transport, security and architectural sectors. Bullet-resistant glass is produced by laminating several layers of glass of different thicknesses together with layers of PVB (polyvinyl butyral) plastic film. The number of layers is governed by the 'threat level' required. The first layer is designed to shatter, thereby absorbing the initial impact, with successive layers absorbing the shock waves. By using glass with a low iron content, transparency is maintained even though panels can be up to 150mm thick.

Bullet-resistant glazing
Produced by: SGG
Stadip Protect®
Manufactured by:
Saint-Gobain Glass
Available from: Solar Glas, UK

more: Glazing 085, 096, 109, 112, 121, 125; Laminated glass 085–086, 103, 115–116, 118, 128

118

Animated

Visual Impact Technology produces a range of laminated glass ↘ with a truly animated visual effect — an optical techno light show.

This is made possible by a patented interlayer system sandwiched between two pieces of clear, tinted, annealed, float or tempered glass. One of the major advantages this type of holographic glass has over other holographic decorative panels is its transparency. What you see is a totally clear sheet, with a range of decorative holographic patterns in the surface. Although logos and other specific designs can be made to order, there is a good range of standard patterns to choose from.

This marriage of light and technology allows for unique ornamentation on glass panels which can be treated in the same way as standard laminated glass products. As with all holographic images it is difficult to appreciate the qualities of the glass without seeing it first hand as the effect changes according to the angle it is viewed from and the direction of reflected light — a real attention-grabber.

Dimensions	**Maximum size: 1000 x 3000mm**
	Up to 25.4mm thick
Material Properties	**High decorative potential**
	Bespoke designs can be produced
	Internal and external applications
	Can incorporate other functional interlayers
	Can be treated in the same way as normal laminated glass
Further Information	**www.vitglass.com**
Typical Uses	**Room dividers; walls; furniture; shower screens; ceiling tiles; conference tables; wash basin inlays; hand rails; insulated units; signage; escalator partitions**

Holographic glass
Produced by: Vitglass

↑ more: Laminated glass 085–086, 103, 115–117, 128

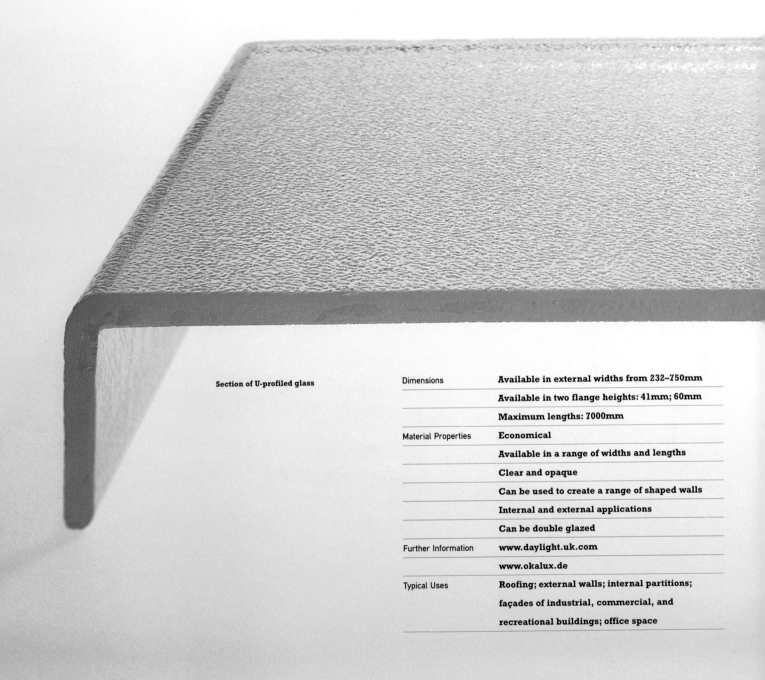

Section of U-profiled glass

Dimensions	Available in external widths from 232–750mm
	Available in two flange heights: 41mm; 60mm
	Maximum lengths: 7000mm
Material Properties	Economical
	Available in a range of widths and lengths
	Clear and opaque
	Can be used to create a range of shaped walls
	Internal and external applications
	Can be double glazed
Further Information	www.daylight.uk.com
	www.okalux.de
Typical Uses	Roofing; external walls; internal partitions; façades of industrial, commercial, and recreational buildings; office space

Structural planks

This is a product that is interesting neither for its use of glass, nor for the type, but rather for the potential within construction that a profiled glass building component can offer. It is a single unit that, when used as a multiple, provides an alternative to conventional sheet glazing ↘.

The U-profiled shape of this glazing product provides a solution for creating flush glass surfaces to be constructed and assembled on-site with no restriction on the size of surface. The inherently strong U-shape fits into an aluminium peripheral frame system and offers a much lower cost than conventional large sheet glazing, while also offering spanning capabilities exceeding 5m without any intermediate support.

The standard finish on the sections is a roughcast glass with a slightly textured pattern, that creates a green, fuzzy, translucent effect when the sections are in place. Although, a clearer smooth finish is also available which can be sandblasted to provide a range of decorative opportunities. And with a large cavity, materials can be added to perform a range of thermal, acoustic or solar functions.

Used horizontally or vertically this chunky, profiled section of glass gives architects and designers the choice to use glass in a cost-effective way which otherwise might not be possible with conventional laminated or insulated glass sheets.

more: Glazing 085, 096, 109, 112, 117, 121, 125

122

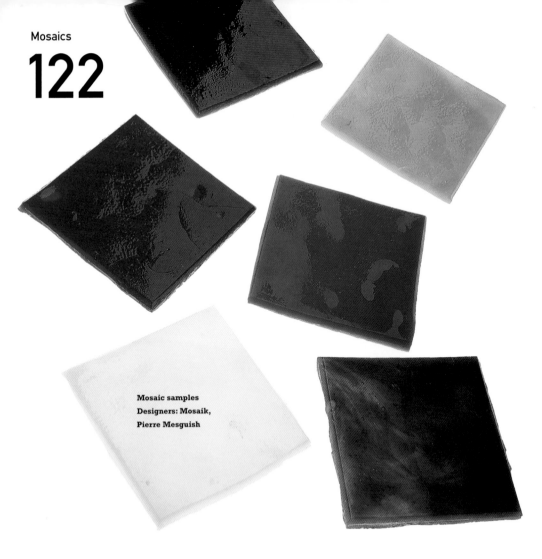

**Mosaic samples
Designers: Mosaik,
Pierre Mesguish**

Unlimited scale

Tiny squares of glass positioned closely together is one of the oldest techniques used for decorating on a large scale. The challenge now is to produce fresh, interesting designs in a different way within new contexts.

Making mosaics is one of the most accessible methods of producing a glass object. There is no heat involved, no expensive moulds or tooling and no machines for grinding or polishing. The skill is in the ability to visualise and interpret a surface and pattern made up of hundreds of small pieces of glass. It is also a method of using glass where there is no limit to the scale. There are two methods of producing mosaic designs: the indirect and the direct method.

Making and installing a mosaic piece — the indirect method:

• First design the motif defining the colours and key areas.
• Collect the coloured glass.
• Draw your design on to a large sheet of brown paper. Stick the glass on to the paper using glue.
• Cut the paper into manageable sections which can be taken on-site.
• Press the glass directly into an adhesive on the surface you want to mosaic.
• When dry, soak the paper and remove.

The direct method speaks for itself as the pattern is laid directly on to the surface on-site by a skilled craftsman.

Material Properties	**Durable**
	Highly decorative
Further Information	**www.mosaik-mesguich.com**
Typical Uses	**Flooring; walls; decorative panels; shower screens; nightclubs; bathrooms; kitchen splashbacks; floors, swimming pools; ornamental pools; company logos; table tops**

Glass bricks have been around for such a long time that their contribution to both the exterior and interior of buildings is taken for granted. But seen objectively they have provided opportunities that would not be possible with conventional sheet glazing products.

These unique, versatile, flexible building blocks were first introduced in the 1930s and can be used in virtually the same way as ceramic bricks, while allowing for a high degree of transparency and light transmission. With a range of surface finishes such as Green Wavey®, Essex®, Flemish-Turquoise® and Grey-Ribbed®, different aesthetic and functional elements can be exploited with varying degrees of transparency.

The blocks are manufactured from two pieces of pressed glass fused ↘ together at a high temperature. The hermetically-sealed blocks are more secure than conventional glazing while maintaining good light transmission.

Unlike conventional sheet glazing, which needs an entire new sheet in the event of a breakage, individual blocks can just be replaced. If one side of the glass panel is broken the other will stay intact. Likewise, if a brick is damaged the wall will stay in one piece compared with traditional single windowpane constructions. Because these blocks offer the flexibility of building with small units, a single wall can boast a range of finishes and colours.

Dimensions	Six sizes from 146 x 146mm to 194 x 194mm
	Thickness: 98.4mm
Material Properties	Fire retardant to British Standard 476
	Better thermal insulation than concrete
	Good sound insulation; Easy to maintain
	Eliminates condensation; Excellent security
	Gives privacy while allowing light in
Further Information	www.luxcrete.co.uk
	www.pittsburghcorning.co.uk
	www.glassblocksunlimited.com
Typical Uses	Exterior and interior walls; corporate and domestic interiors; partition walls; high security areas: banks, embassies, military buildings, police stations and courthouses

Glass brick

Glass block
Produced by: Luxcrete Ltd.

more: Pressed glass 036; Fused glass 020, 111

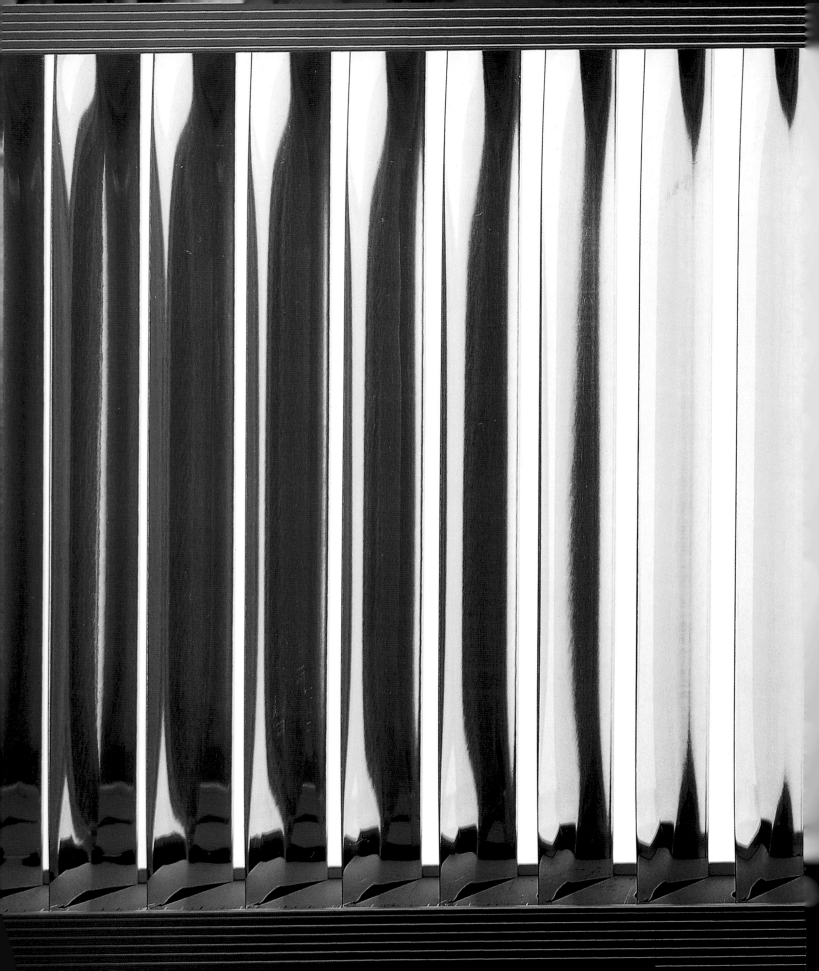

Glazing ⭷ has come a long way since glass discs of magnifying glass proportions were handblown and fitted into square, wooden frames. The primary function of double glazing when it first appeared was to improve sound- and thermal-insulating properties. But the world of double glazing is more than just a glass sandwich to keep you cosy. The range of products offered by just one German producer place insulating glass ⭷ up there with the decorative potential of cast and laminated glazing products.

Okulux® are a German company specialising in insulating glass. Okatech® is the brand name for their product range of panels, which incorporate decorative metallic mesh designs sandwiched in the cavity of the glass panels. But this sandwich filler is not just for decoration – it also reduces solar glare. The wire mesh patterns (customers can choose from a selection of designs) create an interesting surface when viewed at close range and from a distance they create a fairly dramatic light effect.

Other filled units include OkaSolar® and Okaflex® – two hermetically-sealed units which incorporate reflective louvre blades. In the OkaSolar® range, the blades are fixed at a pre-determined angle, but in Okaflex® the blades can be adjusted to vary the amount of light, or to re-direct it upwards on to the ceiling or into the room. Kapilux® is a honeycomb glass structure of plastic tubes which diffuse light and insulate.

Insulating glazing products are developing and improving very quickly. There is even research going on into the possibility of water-filled units for extra insulation. With the current range of insulating glass fillings on the market, the possibilities for new applications and functions for glazing are enormous.

Details of OkaSolar® (left)
and Kapilux®

Sandwich fillings

Dimensions	24 x 6m
Material Properties	Good sound absorption
	Good thermal insulation
	Excellent potential for functional inserts
	A range of glasses can be used for panels
Further Information	www.daylight.uk.com
	www.okalux.de
	www.igo.uk.com
Typical Uses	Internal and external glazing; partitioning;
	general architectural glazing applications:
	sloping or vertical structures, and bolted,
	suspended assemblies

more: Glazing 085, 096, 109, 112, 117, 121; Insulating glass 061

New materials, new fastening techniques, new applications! The All Glass Bridge captures the imagination by using a new material according to an ancient principle. There are many designs where glass is an integral part of the structure – but the All Glass Bridge is unique, and, as the name proclaims, uses no other material.

The idea for a 100% glass structure originated at the Thomas Heatherwick Studio in 1996. The concept rests on using 4000 pieces of 8mm water-jet, clear, toughened glass. Strength is achieved by bonding the edges of the pieces together using a specially developed UV adhesive – one that does not deteriorate with prolonged exposure to direct sunlight.

The basic arch shape provides a non-slip surface but no grip. The solution was to place each piece of glass at a slightly different height to the next, leaving each corner exposed. From the handrail to the fixings, this is a structure that exploits the physical qualities of glass and the supreme strength of UV-bonding.

Dimensions	24 x 6m
Material Properties	**Exceptional strength**
	Invisible joints
Further Information	**www.anthonyhuntassociates.co.uk**
	Thomas Heatherwick Studio, London, UK
	Tel: +44 020 7833 8800
Typical Uses	**Furniture; drinks bottles; glazing;**
	interior shop fittings

Super-strong bonding

All Glass Bridge
Client: Self-initiated project
Designers: Thomas Heatherwick
Studio, Anthony Hunt Associates,
Lighting Design Partnership
Design completed: 1999

Dimensions	19.5 x 2.5m
	Suspended 3.5m off the ground
Further Information	www.jcdainc.com

Light transmission

The Suspended Glass Tower is based on an exploration of architecture where the themes are reflection, refraction and transmission of light with glass as the key player.

The Tower promotes the importance of laminated glass ↘ technologies within architecture by acting as a prototype model for glass shell structures. The intention was to create an engaging sculpture for the visitors to the Hong Kong Convention Center. Its volumetric translucent surface is composed of semi-transparent laminated glass triangles with machined edges. This luminous column of light is suspended by a series of stainless steel tension rods attached to the ceiling of the entrance lobby allowing the sculpture to be viewed from underneath without obstructing the ground plane. The sculpture is artificially lit at night creating a luminous emblem for the Convention Center.

Suspended Glass Tower,
Hong Kong Convention
& Exhibition Center
Architects: Skidmore, Owings
and Merrill, Chicago
Completed: 1997

more: Laminated glass 085–086, 103, 115–118 ↑

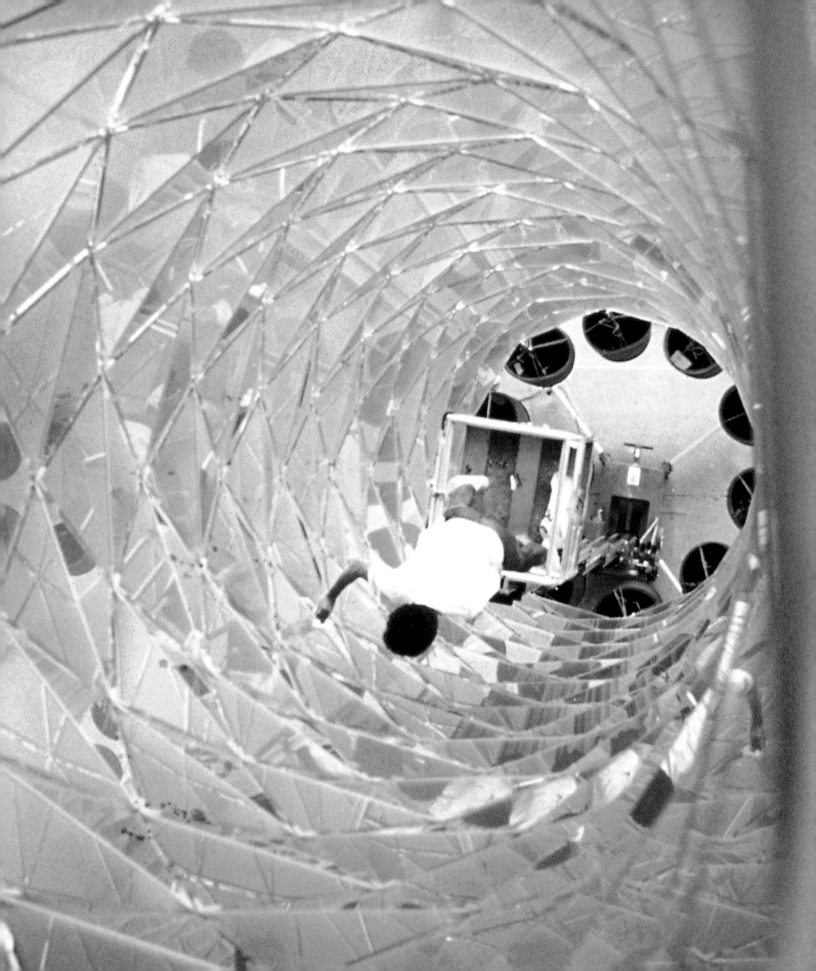

131 Coatings

Michael Anastassiades' mirrored ⬂ products
are curious and captivating. Inspired by vacuum
flasks, he has taken the familiar and established
process of mirroring and applied it to a range of
domestic products. The objects are made from
handmade blown glass and lathe-worked ⬂
borosilicate tubing ⬂.

For the shot glasses, glass is blown into one
mould to make the outside shape; it is then
taken to another mould, which creates the
internal form. Once the glass has been cut,
leaving an open end, a silver nitrate solution
is poured into the cavity. A few minutes later,
the silver ⬂ is deposited on to the glass and
the solution can be poured away. Once the silver
coating is dry it will corrode if left exposed to
the air. To prevent this, a mirrored disc is glued
on the underside to create an airtight seal.

Traditional mirroring production involves the
application of a number of coatings ⬂ to stop
the silver corroding. A series of experiments
led to varnish being used to protect the surface
of the mirrored vases and lampshades.

more: Mirrors 090, 098, 100; Lathe-working 603; Borosilicate glass 016, 049, 052, 062–063, 067, 069, 074, 076–077, 105

Reflections

Dimensions	**250 x 85mm; 370 x 100mm; 500 x 100mm**
Production	**Silvered on to blown and lathe-worked glassware**
Material Properties	**Good insulation properties**
	Decorative finish
	Low to medium tooling
Further Information	**www.michaelanastassiades.com**
Typical Uses	**Scientific instruments; vacuum flasks;**
	mirrors; jewellery

Mirror Vases
Client: Babylon
Designer: Michael Anastassiades
Launched: 1999

more: Silvering 098, 103; Coatings 078, 098, 112, 134–135, 138

Dimensions	Window: 6m high; Thickness: 13.5mm
Material Properties	Clear visibility; Easy cleaning; Can be laminated
	High degree of chemical stability
	High degree of abrasion resistance
	Single or double-sided coating
	Available in clear, float or body-tinted formats
	Can be toughened and screen-printed
Further Information	www.compassglass.co.uk
	www.brinkworth.co.uk
Typical Uses	Dashboards; electrical engineering; computer monitors; measuring instruments; televisions; rear-view mirrors; anti-reflection substrates for sensors; timetable display panels

Invisible

Schott manufacture over 400 types of glass and 50,000 products. One of the world's leading technology-driven companies, their business areas include the manufacture of television screens, consumer glassware, optics, packaging and tubing. They are also a market leader in the manufacturing of anti-reflective glass.

Anti-reflective glass offers a significant reduction in disturbing reflections. Normal glass reflects 8% of light – anti-reflective glass cuts this down to just 1%. Apart from films there are several ways of reducing reflections from glass. Fine-etching the surface gives it a matt finish, but this will only be of use if the image or object is pressed up to the surface of the glass. Another way is by applying a non-reflective interference coating ⬊ which is vacuum-deposited. This process allows the same amount of light transmission but can reduce light reflection to about a tenth of normal non-coated glass when compared with etching.

The Schott range of anti-reflective glass comprises three main product brands: Amiran®, Mirogard® and Conturax®. Amiran® is used specifically for architectural glazing applications; Mirogard® is for picture-framing, and Conturax® for electronic displays.

Storefront with Lumisty
vinyl mfx 1515
Installed: 1999

more: Coatings 078, 098, 112, 132–133, 135, 138

The use of glass beads is a common way of getting road markings to reflect light. The difference with this product is that the markings continue to glow once the car has passed.

Traditionally, the only road markings that reflected light were cats eyes which only work when the powerful beam of a car headlamp is shining directly on to them. Glass beads are hardwearing, cost-effective and reflective, and benefit pedestrians, animals and cyclists as well as cars. This technology has been around for some time but the major obstacle to wider use has been the cost of the phosphorescent powder and mixing it with paint. Product 2000 have overcome this by coating ↘ the beads.

There is no need for baking as the powder is held on to the beads when they are sprinkled and pushed on to the soft surface of the thermoplastic paint — trapping the powder between the sphere and the paint. Ironically, the glass beads are generally made from shattered car windscreens.

Glow in the dark

Material Properties	Benefits pedestrians, animals and drivers
	Hardwearing
	Cost-effective compared with cats eyes
	No power is needed to generate light
	Safe, non-toxic coating
Further Information	www.pottersbeads.com
	Product 2000; Tel: +44 (0)1425 652226
Typical Uses	Garages; warehouses; fire escapes; edges of
	platforms on railway stations; airports; aircraft
	interiors; sleeping policemen

Phosphorescent-coated
road markings

more: Coatings 078, 098, 112, 132–134, 138

Dimensions	6m²
Material Properties	**Films can be changed every six months**
	Window can double up as a projection screen
Further Information	**www.brinkworth.co.uk**
	www.madico.com
	www.polytronix.com
	Architectural Window Films
	Tel: +44 (0)20 8441 4545

24-hr window experience

Window-dressing takes on a whole new meaning with this concept by designer Adam Brinkworth. We have seen examples of decorative effects, both cast, laminated and coloured, but in this context, glass windows are taken beyond decoration and into the theatrical.

This flagship store for the clothes retailer Karen Millen in London's Brompton Road ignores many of the rules of retail design. Four sheets of toughened float glass ◥ covered with a vinyl film front the full six-metre height of the shop, making it impossible to see inside. When it closes, the shopfront functions as a giant screen showing a series of short films produced by students from Central Saint Martin's College of Art and Design.

Clients can change the film covering every six months allowing for the window to be dressed according to different fashions with which to entertain and lure the customer. Another kind of film makes the shop impossible to see inside when standing directly in front but when viewed at an angle the glass magically becomes clear.

Karen Millen, Brompton Road
Designer: Brinkworth
Client: Karen Millen
Refurbished: October 2000

more: Float glass 026, 073, 103, 110

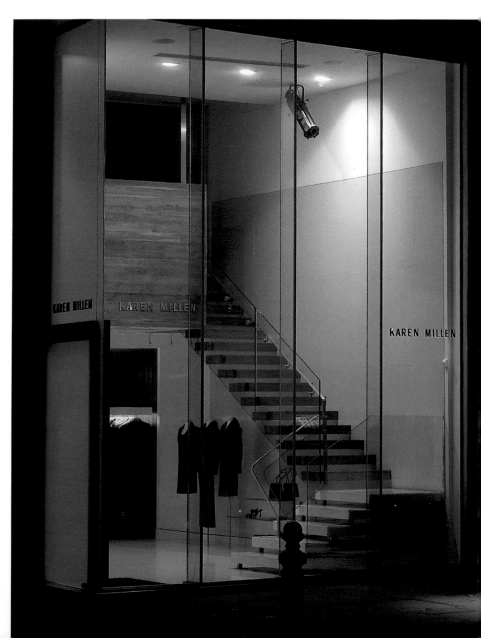

138

Dimensions	170 x 300 x 6mm thickness
Material Properties	Varying degrees of translucency
	Emits a greenish-yellow light lasting approximately one hour
	Good weathering resistance
	Creates a two-dimensional pattern during the day and a three-dimensional effect in the darkness
Further Information	www.gruppe-re.de
	www.rctritec.com
Typical Uses	Interiors; swimming pools; architectural glazing; façades; windows; doors

Onda glass tiles
Designers: Nicole Huttner &
Silke Warchold
Client: Experimental
Launched: 2001

Gruppe RE are two designers interested in finding new applications for existing materials and technology. Inspired by the phosphorescent ink found in plastic security and safety applications, they have produced a unique design for glass tiles, which takes this ink coating ↘ into new territories.

The tiles offer an alternative to the more common ceramic variety by allowing a greater depth of colour possibilities. The screen-printing process they use involves three glass enamels: a first layer of illuminating ink; a second layer of red, and a third layer of turquoise. The three coloured enamels are screen-printed on to clear glass tiles and burnt on to the surface at 650–720°C for two to four minutes, to create a surface with a lasting resilience. Clear Optiwhite glass had to be used for the tiles as the green tint common in most glazing applications acts as a UV-barrier, preventing absorption of UV-light. This multi-layering creates depth so that in daylight the translucent ink allows the red and turquoise to come through, and in the dark only the phosphorescent element can be seen.

Luminous

more: Coatings 078, 098, 112, 132–135

↑

Dimensions	905 x 625 x 600mm
Material Properties	**Removable; Easy to install**
	Cost-effective; Low maintenance
	Decorative and functional applications
Further Information	**www.madico.com**
Typical Uses	**Shop windows; office partitioning; furniture; doors**

Opalux® privacy screening film
with decorative cut-out

Window-dressing

Curtains and blinds seem old-fashioned compared with the range of thin plastic films now available that can transform windows and archictectural glass. From plain acid-etched ↘ textures, coloured films and mirrored effects to films that will appear clear from one angle and opaque from another, glass is going glam. These surfaces can be applied just as easily as they can be replaced.

One of the key advantages of these films is in their ability to dress or undress a window or partition according to changing functions. Because they can be applied directly on-site, films can be removed and replaced at any time. They also allow for complete creative freedom for designing and cutting out specific shapes. But these films are not restricted to decorative applications either – some films can control solar heat gain in buildings and enhance shatter resistance.

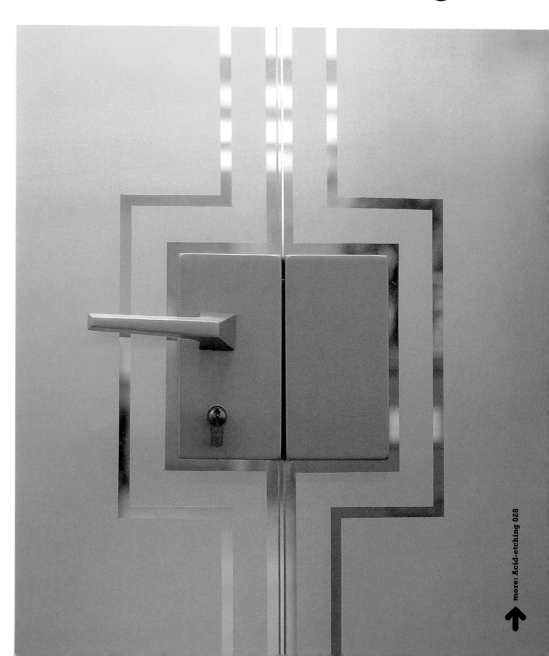

more: Acid-etching 028

141 Appendices

Technical Information

Product	Specific qualities	Method of manufacture	Typical formula
Glass containers, bottles and jars	Relatively cheap when mass produced Resistant to mechanical shock, capable of being filled at very fast rates Some bottling plants fill in excess of 1000 bottles per minute Can be re-used and recycled Can be sterilised at high temperatures Inert, does not impart taste or toxic substances	Automatically blown at high speeds	Soda-lime silica Approximate composition: % SiO_2 74 Na_2O 14 CaO 11 Al_2O_3 1
Flat glass	Relatively cheap Can be toughened Weather resistant Can be coated	Float process Cast and rolled	Soda-lime silica Approximate composition: % % SiO_2 71 Al_2O_3 1 Na_2O 16 MgO 3 CaO 9
Domestic glassware for everyday use in the home and catering	Pleasant appearance Ability to stand up to constant use Does not affect contents	Mouth blown, pressed or fully automatic mass produced	Soda-lime silica Approximate composition: % % SiO_2 74 Al_2O_3 3 Na_2O 16 K_2O 1 CaO 5 B_2O_3 1 MgO 3
Radiation shielding	High density to absorb radiation	Extrusion and casting can be ground and polished to optical precision	Soda-lime silica Approximate composition: % SiO_2 5 PbO 82 B_2O_3 9.7 Al_2O_3 3
Thermometer tubing	Thermal stability over a wide temperature range, retaining transparency	Automatic or hand drawing	Soda-lime silica Borosilicate Lead glass Depends on temperature range required

Product	Specific qualities	Method of manufacture	Typical formula
Laboratory glassware	**High chemical durability** **Low thermal expansion**	**Lampworking (made from tubing by heating and skilful manipulation)** **Mouth and automatic blowing** **Sintering**	**Mainly borosilicate or fused silica for extra low expansion coefficient**
Full lead crystal domestic glassware	**Particularly suitable for artistic hand shaping and mouth blowing** **Brilliant finish, attractive when full or empty** **Comparatively soft; easy to cut and polish or engrave**	**Handmade by skilled craftsmen**	**Lead glass** **Approximate composition:** % **SiO_2 55** **PbO 33** **K_2O 11**
Heat-resistant oven to tableware	**Resistant to thermal shock** **Attractive** **Easy to clean** **Can be used in microwave ovens**	**Automatically pressed or blown**	**Borosilicate glass** **Approximate composition:** % **SiO_2 80** **B_2O_3 12** **Na_2O 4.5** **Al_2O_3 5**
Optical glass	**Wide range of refractive indices** **Wide range of dispersion coefficients** **Perfect homogeneity** **Complete transparency**	**Casting** **Pressing** **Blowing**	**Wide range of compositions** **Depends on application**
Electrical components: cathode-ray tubes; capacitors and resistors; computer components; printed circuits	**Good dielectric properties** **Low electrical losses over a wide range of temperatures** **High operating temperatures**	**Blowing** **Drawing in rod form and in sheets** **Sintering and pressing – glass is ground to fine grains and then subsequently pressed into required shape and fired**	**Wide range of compositions**

Product	Specific qualities	Method of manufacture	Typical formula
Glass building blocks	**Resistant to normal temperature changes** **Resistant to atmospheric conditions** **Mechanical strength** **Attractive** **Translucent**	**Automatic pressing** **Pressed in halves and joined together**	Soda-lime silica Similar to flat glass
Ballotini: minute glass spheres (1–60 microns) which reflect light	**High reflective properties; mixed with paint for road signs and cinema screens**	**Flame drawing** **Velocity of flames draws particles of glass up tower as the softened glass falls on the outside, spheres are formed by surface tension effects**	Soda-lime silica Similar to flat glass
Glass fibre	**High strength to weight ratio** **Resistant to corrosive substances** **Resistant to high temperatures** **Flame resistant** **High electrical resistance**	**Filament drawing** **Continuous filament** **White wool** **Crown process** **Can be woven into textiles or incorporated with plastics to form insulating materials, boat hulls, car bodies**	Soda-lime silica and where resistance to weathering is necessary, a borosilicate glass is used.
Lighting glassware **Electric lightbulbs**	**Economical to produce** **Easy to manufacture by mass production methods** **Resistant to shock** **Impermeable and inert to gas, vapour and liquid** **Durable** **Transparent or translucent**	**Ribbon machine** **produces bulb at the rate of over 1000 per minute** **Blanks used in the manufacture of vacuum flasks are also produced by this machine**	Soda-lime silica **Approximate composition:** % SiO_2 72.5 MgO 3 Al_2O_3 1.3 Na_2O 15.9 CaO 6.5 K_2O 0.3

Product	Specific qualities	Method of manufacture	Typical formula
Special glasses **High pressure mercury vapour lamps** **Aircraft fire-warning sensors** **Glass for encapsulating electric components**	**Low melting point** **Resistance to intense chemical activity of mercury vapour**	**Special glasses can be formed by using manufacturing processes, or, in some cases, laminated on to ordinary glasses, i.e. sodium discharge lamps**	**Wide range of compositions**
Tubing for fluorescent lighting	**Low electrical conductivity** **Resistance to intense chemical activity** **Electrical discharge generates UV-light which then causes fluorescent powder to emit visible light** **High efficiency** **Long life: 3000–5000 hours, i.e. about one year of continuous use**	**Automatic drawing**	**Soda-lime silica** % SiO_2 72.5 Na_2O 14.6 Al_2O_3 2.6 K_2O 1.2 CaO 5.7 B_2O_3 0.3 MgO 2.9
Domestic and industrial shades and bulkhead lights: including lenses for traffic lights, car lights and railway signal lights	**Resistant to high temperatures** **Resistant to thermal shock** **Resistant to weathering** **Accurate and non-fading colour: subject to strict BS specifications**	**Mouth blowing** **Hand and automatic pressing depending on quantities required**	**Soda-lime silica** **Laminated with opal glass** **Borosilicate glasses and opal glasses**

This chapter has been reproduced by kind permission of British Glass Ltd.

| What is glass? | Glass is a product obtained by the fusion of several inorganic substances, of which normally silica (SiO_2) in the form of sand is the main one. The fused mass is cooled to ambient temperature at a rate fast enough to prevent crystallisation, i.e., the molecules cannot arrange themselves into a crystalline pattern. The fast rate of cooling to prevent crystallisation applies to transparent glasses, whereas in the case of translucent or opal glasses, the rate of cooling is such as to produce a pre-determined level of crystal formation. |

| Types of glasses | A large variety of glass with different chemical and physical properties can be made by a suitable adjustment to chemical compositions. Further sections in this chapter deal with various glasses, including crystal and optical glasses of high refractive index and high lead content. |

| Commercial glasses | The main constituent of practically all commercial glasses is sand. Sand by itself can be fused to produce glass but the temperature at which this can be achieved is about 1700°C. Adding other chemicals to sand can considerably reduce the temperature of fusion. |

The addition of sodium carbonate (Na_2CO_3), known as soda ash, in a quantity to produce a fused mixture of 75% silica (SiO_2) and 25% sodium oxide (Na_2O), will reduce the temperature of fusion to about 800°C. However, a glass of this composition is water soluble and is known as water glass. In order to give the glass stability, other chemicals like calcium oxide (CaO) and magnesium oxide (MgO) are needed. The raw materials used for introducing CaO and MgO are their carbonates $CaCO_3$ (limestone) and $MgCO_3$ (dolomite), which when subjected to high temperatures give off carbon dioxide leaving the oxides in the glass. Most commercial glasses, whether for containers, i.e. bottles and jars, flat glass for windows or for drinking glasses, have somewhat similar chemical compositions of:

70% – 74%	SiO_2 (silica)
12% – 16%	Na_2O (sodium oxide)
5% – 11%	CaO (calcium oxide)
1% – 3%	MgO (magnesium oxide)
1% – 3%	Al_2O_3 (aluminium oxide)

Within these very wide limits the composition is varied to suit a particular product and production method. The raw materials are carefully weighed and thoroughly mixed, as consistency of composition is of utmost importance. To the mixture of chemicals a further raw material is added – broken glass, called cullet. Cullet can come from factory rejects; it can be collected by the public in bottle banks or from the bottling industry. Almost any proportion of cullet can be added to the mix (known as batch), provided it is in the right condition, and green glass made from batch containing 95% cullet is by no means uncommon. Although the glass collected in bottle banks may come from several manufacturers, it can be re-used by any one of them, as container glass compositions have been harmonised to make this possible. It is, however, important that glass colours are not mixed and that the cullet is free from impurities, especially metals and ceramics. Flat glass is similar in composition to container glass except that it contains a higher proportion of magnesium oxide.

| Other types of glasses | Glasses vary widely in their chemical make-up; indeed, there are very few elements in the periodic table that have not been incorporated in a glass of some kind. However, most of the glasses produced commercially on a large scale may be classified into three main groups: soda-lime, lead and borosilicate, of which the first is by far the most common. |

Soda-lime glasses	These are the most common commercial glasses and have been described in previous chapters. The chemical and physical properties of soda-lime glasses make them ideal for use in windows. The nominally colourless types transmit a very high percentage of visible light and hence have been used for windows since at least the time of the Romans. Soda-lime glass containers are virtually inert, and so cannot contaminate the contents inside or affect the taste. Their resistance to chemical attack from aqueous solutions is good enough to withstand repeated boiling (as in the case of preserving jars) without any significant changes in the glass surface. One of the main disadvantages of soda-lime glasses is their relatively high thermal expansion. Silica does not expand very much when heated but the addition of soda has a dramatic effect in increasing the expansion rate and, in general, the higher the soda content of a glass, the poorer will be its resistance to sudden changes of temperature (thermal shock). Thus, care is needed when soda-lime containers are filled with hot liquids to prevent breakages due to rapid thermal expansion.
Lead glasses	The use of lead oxide instead of calcium oxide, and of potassium oxide instead of all or most of the sodium oxide, gives the type of glass commonly known as lead crystal. The traditional English full lead crystal contains at least 30% lead oxide (PbO) but any glass containing at least 24% PbO can be legitimately described as lead crystal according to the relevant EEC directive. Glasses of the same type, but containing less than 24% PbO, are known simply as crystal glasses, some or all of the lead being replaced in these compositions by varying amounts of the oxides of barium, zinc and potassium. Lead glasses have a high refractive index and relatively soft surface so that they are easy to decorate by grinding, cutting and engraving. The overall effect of cut crystal is the brilliance of the two. Glasses with even higher lead oxide contents (typically 65%) may be used as radiation-shielding glasses because of the well-known ability of lead to absorb gamma rays and other forms of harmful radiation.

Types of glass

Borosilicate glasses

As the name implies, borosilicate glasses, the third major group, are composed mainly of silica (70–80%) and boric oxide (7–13%) with smaller amounts of the alkalis (sodium and potassium oxides) and aluminium oxide. They are characterised by the relatively low alkali content and consequently have good chemical durability and thermal shock resistance. Thus they are permanently suitable for process plants in the chemical industry, for laboratory apparatus, for ampoules and other pharmaceutical containers, for various high intensity lighting applications and as glass fibres for textile and plastic reinforcement. In the home they are familiar in the form of ovenware and other heat-resisting ware, possibly better known under the trade name of the first glass of this type to be placed on the consumer market – Pyrex.

Special glasses

Glasses with specific properties may be devised to meet almost any imaginable requirement, the main restriction normally being the commercial considerations, i.e., whether the potential market is large enough to justify the development and manufacturing costs. For many specialised applications in chemistry, pharmacy, the electrical and electronics industries, optics, the construction and lighting industries, glass, or the comparatively new family of materials known as glass ceramics, may be the only practical material for the engineer to use.

Vitreous silica

As mentioned previously, silica glass or vitreous silica is of considerable technical importance. However, the fact that temperatures above 1500°C are necessary in the melting makes the transparent variety (often known as fused quartz or quartz glass) expensive and difficult to produce. The less expensive alternative for many applications is fused silica, which is melted at somewhat lower temperatures; in this case small gas bubbles remain in the final product which is therefore not transparent. Another substitute for vitreous silica can be produced by melting a suitable borosilicate glass and then heating it at around 600°C until it separates into two phases. The alkali-borate phase may be bleached out with acids, leaving a 96% silica phase with open pores of controllable size which can be converted into clear glass. Porous glasses of this kind, commonly known as Vycor, from the first commercial version produced by Corning Glass Works Ltd, may be used as membranes for filtration purposes and for certain biological applications.

Alumino-silicate glasses

A small, but important, group of glasses is that known as alumino-silicate, containing some 20% aluminium oxide (alumina-Al_2O_4) often including calcium oxide, magnesium oxide and boric oxide in relatively small amounts, but with only very small amounts of soda or potash. They tend to require higher melting temperatures than borosilicate glasses and are difficult to work, but have the merit of being able to withstand but have the merit of being able to withstand high temperatures while also maintaining good resistance to thermal shock. Typical applications include combustion tubes, gauge glasses for high pressure steam boilers, and halogen-tungsten lamps, as they are capable of operating at temperatures as high as 750°C.

Alkali-barium silicate

In normal operation, a television produces X-rays which need to be absorbed by the various glass components. This protection is afforded by glasses with minimum amounts of heavy oxides (lead, barium or strontium). Lead glasses are commonly used for the funnel and neck of the tube, while glasses containing barium are usually employed for the face or panel.

Borate glasses

There is a range of glasses, containing little or no silica, that can be used for soldering glasses, metals or ceramics at relatively low temperatures. When used to solder other glasses, the solder glass needs to be fluid at temperatures (450–550°C) well below that at which the glass to be sealed will deform. Some solder glasses do not crystallise or denitrify during the soldering process and thus the mating surfaces can be reset or separated; these are usually lead borate glasses containing 60–90% PbO with relatively small amounts of silica and alumina to improve the chemical durability. Another group consists of glasses that are converted partly into crystalline materials when the soldering temperature is reached, in which case the joints can be separated only by dissolving the layer of solder by chemical means. Such denitrifying solder glasses are characterised by continuing up to about 25% zinc oxide. Glasses of a slightly different composition (zinc-silicoborate glasses) may also be used for protecting silicon semi-conductor components against chemical attack and mechanical damage. Such glasses must contain no alkalis (which can influence the semi-conducting properties of the silicon) and should be compatible with silicon in terms of thermal expansion. These materials, known as passivation glasses, have assumed considerable importance with the progress made in microelectronics technology in recent years that has made the concept of the 'silicon chip' familiar to all.

Phosphate glasses

Most types of glass are good insulators at room temperature, although those with a substantial alkali content may well be good conductors in the molten state; conductivity depends mainly on the ability of the alkali ions in the glass to migrate in an electric field. However, some glasses that do not contain alkalis conduct electrons which jump from one ion to another. These are known as semi-conducting oxide glasses and are used particularly in the construction of secondary electron multipliers. Typically they consist of mixtures of vanadium pentoxide (V_2O_5) and phosphorous pentoxide (P_2O_5).

Chalcogenide glasses

Similar semi-conductor effects are also characteristic of a series of glasses which can be made without the presence of oxygen (non-oxide glasses). These may be composed of one or more elements of the sulphur group in the periodic table combined with arsenic, antimony, germanium and/or the halides (fluorine, chlorine, bromine, iodine). Some of them have potential use as infra-red transmitting materials and as switching devices in computer memories because their conductivity changes abruptly when particular threshold voltage values are exceeded, but most have extremely low softening points and much poorer chemical durability than more conventional glasses.

Glass ceramics

An essential feature of glass structure is that it does not contain crystals. However, by deliberately stimulating crystal growth in appropriate glasses it is possible to produce a range of materials with a controlled amount of crystallisation so that they can combine many of the best features of ceramics and glass. Some of these 'glass ceramics', formed typically from lithium alumino-silicate glasses, are extremely resistant to thermal stock and have found several applications where this property is important, including cooker hobs, cooking ware, windows for gas or coal fires, mirror substrates for astronomical telescopes and missile nose cones.

Special applications

Different forms and varieties of glass are used in almost every conceivable aspect of human life. Architecture, food and drink, laboratory equipment, instrumentation, the chemical, nuclear and electrical industries, lighting, optics – the list is endless. For some areas of application, one type of glass predominates: for example, soda-lime glass is used almost universally in the building and packaging industries while borosilicate tends to be standard in the chemical processing industry. However, for some purposes a wide range of glasses is required to meet different requirements, as is the case with optical glass, glasses for sealing to metals and glass fibres.

Optical glasses

Glasses can be designed to meet almost any specified combination of optical properties, of which the most important are the refractive index (representing the deviation of a ray of light striking the glass at an oblique angle) and the dispersion (the dependence of the refractive index on wavelength). Glasses with high dispersion relative to refractive index are called flint glasses, while those with relatively low dispersions are called crown glasses. Typically, flint glasses are lead-alkali-silicate compositions whereas crown glasses are soda-lime glasses. The substitution of other oxides permits considerable variations to be achieved. Thus barium crown (barium borosilicate), barium flint (barium-lead-silicate), borosilicate crown (sodium borosilicate) and crown flint (calcium lead-silicate) are all widely used. Phosphorous and the rare earths, especially lanthanum, may also be valuable ingredients in some optical glass compositions. The inclusion of transition elements (copper, titanium, vanadium, chromium, manganese, iron, cobalt or nickel) in glass produces strong absorption bands in the ultraviolet part of the spectrum as well as broad bands in the visible and infra-red, enabling a series of colour filters and glasses with modified transmission properties in the ultraviolet and infra-red to be produced. The use of rare earths has less effect on colour but it is of particular significance in the manufacture of laser glasses, most of which contain neodymium. The neodymium ions in the glass, when stimulated, emit radiation at a particular wavelength ($1.06\mu m$) and this is transformed into high-intensity coherent optical data, and for various measurement functions in industry. A characteristic of some optical glasses is that when they are exposed to ultraviolet or short-wave infra-red radiation (as with sunlight) they become dark, but when removed from such exposure they revert to their original state.

These, known as photochromic glasses, include in their composition silver halide crystals produced by adding silver salts and compounds of fluoride, chlorine or bromine (the halides) to the base-glass (normally borosilicate). Controlled thermal treatment during and after melting causes extremely small phase separations to occur and these are responsible for the reversible darkening effect.

Sealing glasses

Another application for which a large variety of glass compositions is used is sealing to metals for electrical and electronic components. Here, the available glasses may be grouped according to their thermal expansion which must be matched with the thermal expansions of the respective metals so that sealing is possible without excessive strain being induced by the expansion differences. For sealing to tungsten, in making incandescent and discharge lamps, borosilicate alkaline earths-aluminous silicate glasses are suitable. Sodium borosilicate glasses may be used for sealing to molybdenum and the iron-nickel-cobalt (Fernico) alloys are frequently employed as a substitute, the amount of sodium oxide permissible depending on the degree of electrical resistance required. With glasses designed to seal to Kovar alloy, relatively high contents of boric oxide (approximately 20%) are needed to keep the transformation temperature low and usually the preferred alkali is potassium oxide so as to ensure high electrical insulation. Where the requirement for electrical insulation is paramount, as in many types of vacuum tube and for the encapsulation of diodes, a variety of lead glasses (typically containing between 30% and 60% lead oxide) can be used.

This chapter has been reproduced by kind permission of British Glass Ltd.

Crafts and products

www.ssgi.demon.co.uk/IntroEng.htm

Decorative and bespoke glassware from ornamental to contemporary.

www.livetile.cz/en/first.html

With the use of unique technology the glass is cut, ground off and an exact serigraphy expresses depth and individual look of the tiles. High durability is the result of firing. Glass tiles are highly resistant to mechanical and chemical attacks and to the effects of climate. LIVE TILE, a unique glass tile protected by an original Czech patent, utilises optical decomposition of light after passing through the tile.

www.rubinoglass.com

Glass art. Items are hand blown working in a traditional Italian style.

www.warrenlangley.net/index.htm

Australian glass artist.

www.bevel.co.uk

Knaresborough Glass – specialists in the fast production of bevelled and polished edge glass and mirrors to both the public and trade.

www.contractglass.co.uk

Shelves; bar tops; sink tops; reception desks; glass buildings; bridges; display cases; glass floors.

www.starshine.at

Coloured glass beads.

www.justglass.org.uk

Saint Andrew's University glassblowing.

www.mariannebuus.com

Craft glassmaker.

www.columbia-glass.co.uk

Funky glassware.

www.aanoon.demon.co.uk

Aaronson Noon is a specialist glassmaking company producing a wide range of original and distinctive glass products, all handmade.

www.bsweden.com

Swedish producer of glass lamps.

www.seramico.com

Hand blown solid glass doorknobs.

www.jpozniak.com/images.htm

Designer producing a range of unique glassware.

www.orrefors.se

Unique one-off glass, with art glass and utilitarian wares.

www.igloo.uk.com/laminated.html

Glass wash basins.

Industrial

www.merkad.com

Glass moulds for machine and accessories used in glass production, created by utilizing the Automatic Press, Press-Blow, Blow-Blow, Stemware Line and Spinning methods.

www.colorlites.com

An established company specialising in the coating of glass, mainly for the lighting and bottle industries. Coloured glass can take many different effects by the way the different types of colour are applied. Spraying of many small components can occur in large and small runs.

www.saint-gobain-glass.com

The Flat Glass Division of the SAINT-GOBAIN Group offers an extensive range of glass and glazing products for the building industry. These are used in particular in housing (small and large windows, internal decoration), in street furniture, in the façades of commercial buildings and in major constructions such as the Pyramid at the Louvre in Paris, or the Charlemagne Building at the European Commission in Brussels.

www.lewisandtowers.co.uk

For over 120 years Lewis & Towers Ltd has been a designer and manufacturer of specialist glass containers.

www.bibby-sterilin.co.uk

Major UK producer of borosilicate and other glass laboratory wares. Products for other markets can be custom made. Also supply and work glass tube.

www.agc.co.jp/english/index.htm

The company, which began as a sheet glass manufacturer, is now expanding the technological envelope on four fronts: glass, chemicals, ceramics and electronics. Asahi Glass manufactures products for almost every field of industry including construction, transportation, telecommunications, medicine and environmental protection, as well as for consumer use.

www.corning.com

One of the world's leading glass producers, specialising in a range of technology-led product sectors.

www.pirelli.com

Produce fibre optics.

www.glassblower.co.uk

Products which are individually designed to the customer's requirements and produced to specification. The breadth of glassware produced ranges from the smallest laboratory apparatus to full scale plant processing equipment. They can repair almost any item, including complete rebuilds of complicated, expensive items.

www.lambertsglass.com

One of the few remaining production sites of handcrafted, mouth blown sheet glass in the world, producing a range of decorative glass.

www.accu-glass.com

BDAG produces precision glass tubing to customer specifications. An innovative glass drawing process allows them to produce tubing with unique geometric shapes designed for the customer's application.

www.schott.com

A leading company in glass.

www.glaverbel.com

The Glaverbel Group is a flat glass producer with industrial locations throughout Europe and a worldwide commercial network.

www.beatsonclark.co.uk

Beatson Clark specialise in providing packaging solutions for niche brands, and complete product lines for customers with variable needs. They supply glass packaging containers to the pharmaceutical, food and drink markets worldwide.

wwwhere.else

www.cricursa.com/pages/inicio/ini_productos_i.htm

Laminations of natural materials.

www.radnoti.com

Radnoti Glass Technology, Inc. provide the world with research glassware – from the Tissue Organ Bath systems and components through custom OEM glassware fabrication.

www.thewindowman.co.uk

Double glazing portal.

www.laxandshaw.com

A division of Associated British Foods Plc – formed by the merger of Lax & Shaw and Gregg & Co, produce glass containers.

Associations

www.instmat.co.uk/index.htm

The Institute of Materials – Incorporated by Royal Charter, the Institute of Materials serves the international materials community through its wide range of learned society activities and by acting as the professional body for materials scientists and engineers.

www.glasspages.com

Glasspages is a global directory of glass companies, from glass melters and manufacturers to designers and fitters.

www.stainedglass.org

The Stained Glass Association of America is a non-profit association founded in 1903 to promote the development and advancement of the stained and decorative art glass craft.

www.glass.org

Founded in 1948, the National Glass Association (NGA) is the largest trade association representing the flat (architectural and automotive) glass industry. NGA's more than 4900 member companies and locations reflect the entire vertical flat glass market. To support this ever-changing industry, NGA produces products and services specifically for the industry.

www.britglass.co.uk

The British Glass Manufacturers Confederation has over 100 members comprising glass manufacturers and supply and user companies. It promotes glass as the first choice material in containers, flat, domestic, scientific and fibre applications. Also provides a comprehensive range of technical support to the glass industry worldwide.

www.iop.co.uk

The Institute of Packaging – 'The professional body for the packaging industry aims to advance public education in and to improve the technology of packaging in all its aspects, in particular by advancing the education and training of persons engaged in or interested in the occupation of packaging.'

www.sgt.org

The Society of Glass Technology exists to serve people who are interested in the production, properties or uses of glasses, whether from a commercial, aesthetic, academic or technical viewpoint. It is a non-profit making organisation serving a worldwide membership, publishing journals and text books, organising meetings, symposia and conferences on glass related topics, coordinating the activities of special interest groups and technical committees, and providing a communication framework geared to the needs of the glass community.

www.glassassociation.org.uk

The Association has wide-ranging expertise.

www.glass-ts.com

Glass Technology Services (GTS).

www.worldofglass.com

Website for glass centre at St Helens.

www.lgic.glass-info.com/resource/network.asp

The North American Laminated Glass Information Center (LGIC) is sponsored by Solutia Inc., supplier of Saflex polyvinyl butyral (PVB) plastic interlayer, the world's leading brand of laminated glass plastic interlayer. The North American LGIC, based in St Louis, Missouri, is part of the worldwide network of Laminated Glass Information Centers that include operations in Belgium, France, Italy, and the UK.

www.usglassmag.com

US Glass magazine is a monthly publication that serves the architectural, fenestration, metal and glazing industries. US Glass has the largest circulation of any glass magazine. This website offers industry news and information on educational industry events.

www.glassonline.com

Portal for the glass industry.

www.glassonweb.com

Glass On Web is an independent guide for the flat glass industry. It is designed to help you find topics related to flat glass quickly and easily.

www.glasspac.com

An information resource on glass packaging. It aims to raise the profile of glass as a packaging material.

www.glasshotline.com

China Glass Hotline – the online trade fair for the glass industry.

www.glass-training.co.uk

The National Training Organisation for glass and related industries.

Architectural

www.omnidecor.it

Italian company producing decorative flat float glass.

www.aecportico.co.uk

Laminated glass information centre and architectural sourcing.

www.creative-glass.co.uk

Contemporary commissions for private and corporate customers. From large-scale architectural installations to challenging period restorations.

www.saflex.com

Contacts to support customers' needs and efforts in specifying and/or using laminated glass made with Saflex® in architectural applications.

Recycling

www.recyclingglass.co.uk

Educational site for glass recycling.

www.nrf.org.uk

The National Recycling Forum is an independent forum managed by Waste Watch.

www.imsa.it

Wide variety of products which satisfy customer needs for the processing of flat glass for the construction and furniture industries.

www.orac.sund.ac.uk/~es0nli/mscdir/glashom.htm

Glass Recycling in the UK.

pp4–5 Table of Elements – Whiskey and Drinking Glasses, with thanks and acknowledgement to Karim Rashid Inc., photography by Leonardo Glaskoch; pp6–7 Deep carved sandblasted glass with thanks and acknowledgement to Fusion Glass Designs Ltd; p8 Blow and Blow process bottle, with thanks and acknowledgement to Vetreriebrunni; pp14–15 Ghost Chair, with thanks and acknowledgement to Fiam Italia; pp16–17 Twisted Glass Cutlery and Oil & Vinegar container, with thanks and acknowledgement to Jhan Stanley; pp18–19 Probe Series, with thanks and acknowledgement to Emma Woffenden; p21 Detail from fused wall piece, with thanks and acknowledgement to Amy Cushing; p22 Block Lamp by Harri Koskinen, with thanks and acknowledgement to Design House, Stockholm; p24 The Double Life of a Wine Bottle, with thanks and acknowledgement to Jukka Isotalo; pp26–27 Kiln-cast glass, with thanks and acknowledgement to Fusion Glass Designs Ltd.; p28 Sandblasting detail, photography by Xavier Young; p29 Lightbulb, photography by Xavier Young; pp30–31 Marbles, photography by Xavier Young; pp32–33 Murano Glass Bowl, with thanks and acknowledgement to Langfords & Co. and Norton Cowan Communications; pp34–35 View One, detail of partition wall for Leeds City Gallery, with thanks and acknowledgement to Zara Maltman; pp36–37 Lemon Squeezer, photography by Xavier Young; pp38–39 People Sculptures, with thanks and acknowledgement to Rocco Borghese; p43 Float Series, with thanks and acknowledgement to the Chihuly Studio; pp44–45 Prosthetic Eye, with thanks and acknowledgement to Paul McClarin, photography by Xavier Young; pp46–47 Designs from Sweet Revolution glass project, with thanks and acknowledgement to Marco Sousa Santos and Proto Design; pp48–49 Wagenfeld Teapot, with thanks and acknowledgement to Schott Jena Glass; p50 Thick and Thin Wine Glass, with thanks and acknowledgement to Chris Lefteri, photography by Richard Davies; pp52–53 Marc Newson glasses, with thanks and acknowledgement to Iittala Glass; p55 Press and Blow process storage jar, with thanks and acknowledgement to Vetreriebrunni; pp56–57 Glass Object and Glass Lamp, with thanks and acknowledgement to Gijs Bakker Design; pp60–61 Glass Fibre, photography by Xavier Young; p62 Izzika Tray, with thanks and acknowledgement to Zanotta, photography by Marino Ramazzotti; p63 Detail of glass tube, photography by Xavier Young; pp64–65 Glass Fibre Chair, with thanks and acknowledgement to Aldo Bakker; p66 Hollow Glass Beads, with thanks and acknowledgement to 3M; p67 Pyrex oven dish, with thanks and acknowledgement to Corning, photography by Xavier Young; p68 Glass Beads, photography by Xavier Young; p69 Glass Flakes, photography by Xavier Young; p70 Black Label Range, with thanks and acknowledgement to Samsonite; p72 Space Shuttle, with thanks and acknowledgement to NASA; p73 Float glass process, with thanks and acknowledgement to Pilkington Glass; p74 Crystal Champagne Glass for Ritzenhoff Cristal, with thanks and acknowledgement to Karim Rashid Inc., photography by Ilan Rubin; pp76–77 Pyrex body jewellery, with thanks and acknowledgement to Bodybead.com, photography by Xavier Young; pp78–79 Self-cleaning glass, with thanks and acknowledgement to Pilkington Glass; p83 Fibre optics, with thanks and acknowledgement to Corning; p84 Ceramic Cooker Hob, with thanks and acknowledgement to Schott; p85 Bombay Sapphire Fishtanks, with thanks and acknowledgement to Saint Gobain; pp86–87 Glass Sound® Loudspeaker and Techno Sound Wall®, with thanks and acknowledgement to Glas Platz®; pp88–89 Solar Century colour cells, with thanks and acknowledgement to Solar Century, Big Brother House photography by Trish Littler; p90 Electrochromic Mirrors, with thanks and acknowledgement to Gentex; p91 Bioglass® Douek-MED® shapes, with thanks and acknowledgement to USBiomaterials; pp92–93 Television Tube, with thanks and acknowledgement to Corning; pp96–97 Georgian Wire Square, with thanks and acknowledgement to Jhan Stanley; p98 Zen 1 Mirror, with thanks and acknowledgement to Rebecca Newnham, photography by David Bird; p99 Black Sea Dichrolam™, with thanks and acknowledgement to John Blazy; pp100–101 Brilliant-cut sample, photography by Xavier Young; pp102–103 UV-bonded glass sample, with thanks and acknowledgement to Glass Design Ltd.; pp104–105 Flat panel display glass sample, with thanks and acknowledgement to Schott; pp108–109 Kiln-cast decorative panels, with thanks and acknowledgement to Ozone Glass; p110 Cellbond's B-clear sandwich panel, with thanks and acknowledgement to Cellbond Composites Ltd; p111 Lace Construction, with thanks and acknowledgement to Ruth Spaak; pp112–113 Interior detail of the British Museum Great Court, with thanks and acknowledgement to Foster and Partners, photography by Nigel Young; pp114–115 The Millenium Wheel, photography by Ian Lambot; p116 Blue Crack 2, with thanks and acknowledgement to George Papadopoulos, photography by Andrew Lamb; p117 Bullet-resistant glazing, with thanks and acknowledgement to Solar Glas; p118 Holographic glass, with thanks and acknowledgement to Vitglass; pp120–121 U-profiled glass section, with thanks and acknowledgement to Daylight; p122 Mosaic samples, with thanks and acknowledgement to Mosaik and Pierre Mesguish, photography by Xavier Young; p123 Glass blocks, with thanks and acknowledgement to Luxcrete Ltd. and Slade PR Co. Ltd.; p124 Okasolar® detail, with thanks and acknowledgement to Okalux; p125 Kapilux® detail, with thanks and acknowledgement to Okalux; pp126–127 All Glass Bridge, with thanks and acknowledgement to the Thomas Heatherwick Studio; pp128–129 Suspended Glass Tower, Hong Kong Convention & Exhibition Center, with thanks and acknowledgement to James Carpenter Design Associates Inc.; pp132–133 Mirror Vases, with thanks and acknowledgement to Michael Anastassiades; p134 Storefront with Lumisty vinyl mfx 1515, with thanks and acknowledgement to Rebecca Ashley and Schott; p135 Phosphorescent-coated road markings, with thanks and acknowledgement to Chris Lefteri; pp136–137 Karen Millen storefront, with thanks and acknowledgement to Architectural Window Films and Brinkworth Design Ltd., photography by Richard Davies; p138 Onda glass tiles, with thanks and acknowledgement to Gruppe RE; p139 Opalux® privacy screening film with decorative cut-out, with thanks and acknowledgement to Architectural Window Films, photography by Rodney Harrigan; pp146–147 Cascade, with thanks and acknowledgement to Ruth Spaak.

The best thing about writing a book as opposed to designing a product is the chance to publicly thank all the people involved in its creation.

So huge thanks again to Nicole Mendelsohn for all her hard work in unearthing and chasing the pictures. To Becky Moss for her editorial guidance and Luke Herriott for his art direction. To Xavier Young for his brilliant photography and for knowing exactly what I had in mind. And thanks to everyone else at RotoVision who played a part in bringing this most brilliant of projects together.

A very big thanks to Robin Jones for all his ideas, suggestions and help, and sorry I forgot last time. Thanks also to Margaret Pope for her ideas and suggestions. Many thanks to Fusion who provided the cover and a big thank you to Sonya Dyakova at Frost for her creative vision and design.

Thanks also to Frank Ward, George Fletcher and Rebecca Ashley at Schott and Emi at Corning. To Simon Bolton for his continued and most generous support. Thanks also to Jackie, Jamie, Caroline, Nick, Paul, Andrew and Mark — sorry for being so unsociable but here is why.

Thanks to Doni and KC for lending me their gear. To Thalia for being one of the first people who read my scribblings. To Alex and Jon Issberner who I also forgot to thank in the first book. To David, Victoria and Silas for great weekends.

Finally, huge thanks to Terry, Jane, Theo, Chris, Christina, Paul, Nicholas, Elizabeth, Harry, John and Susan, and everyone else in the big family, and lastly, my wife Alison for her unending patience and support.

Thank you

Abbe, Ernst 067, 076
acid-etching 028, 139
alkali-barium-silicate glass 092
All Glass Bridge 126–127
Alto, Alvar 052
alumino-silicate glass 064, 068, 072, 074, 084, 150
 beads 068
 glass ceramics 084
 glass fibres 064
 space shuttle 072
Amiran® 134
Anastassiades, Michael 132, 133
Anthony Hunt Associates 127
anti-reflective glass 134
automotive technology 078–079, 090

Babylon 133
bakeware 067
Bakker, Aldo 064–065
Bakker, Gijs 056–057
Ballotini 144
Barret, Neil 071
bench-working 063
bent laminated glass 114–115
Bioglass® 091
Black Label Range 070–071
Blazy, John 099
blending glass 020
Block Lamp 022–023
blocks 123, 144
blow and blow process 054–055
blow moulding 054–055
blown glass 009, 010, 042–057, 142, 143, 145
 borosilicate glass 016, 049, 052, 062–063, 067, 069, 074,
 076–077, 105, 132
 glass eyes 044–045
 hand blown glass 046–047, 051–053, 056–057
 hollow ware 052
 mass production 054–055
 mirrored products 132
 spheres 042–043
 tableware 046–047
 Thick and Thin Wine Glass 050–051
Boeri, Cini 014
Bombay Sapphire Fishtanks 085
bonding 103, 126–127
borate glass 150
Borghese, Rocco 038
borosilicate glass 016, 049, 052, 062–063, 067, 074, 076–077,
 105, 132, 151
 flakes 064, 066, 069, 088
 hollow ware 052
 lampworking 016, 038, 044, 063, 076
 mirrored products 132

Pyrex 067
rods 020, 033, 062
technical information 142–145
tubing 063
ultra-thin 105
bottles
 cold-worked recycled 024–025
 mass production 054, 055
 technical information 142
Branzi, Andrea 062
bricks 123, 144
brilliant-cutting 100, 103
Brinkworth, Adam 136
British Museum Great Court 112–113
building blocks 123, 144
bullet-resistant glass 117

cast glass 018, 023, 096
cathode-ray tubes 092, 143
Cellbond Architectural 110
ceramics 084, 150–151
Ceran® 084
chalcogenide glass 150
Chihuly, Dale 042
clear to opaque glass 085
clothing 070–071
CNC-cutting 103, 112
coatings 078, 098, 112, 132–135, 138
cold-worked recycled bottles 024–025
colour sequencing 20–1
colours 020, 028, 030, 033–034, 138, 151
conductivity 150
Conturax® 063, 134
core-forming 010, 016
Corning Glass 029, 067, 076, 082, 150
crown glass 151
cryolite 044
cullet 018, 148
Cushing, Amy 020
cutting
 brilliant- 100, 103
 CNC- 103, 112
 fused glass 020, 111, 123
 lead crystal 051, 074

3D-frosting 028
Danner process 063
decorative glass
 brilliant-cutting 100, 103
 Dichrolam™ 099
 kiln-cast panels 108–109
 laminated 116
Design House, Stockholm 023
dichroic glass 099, 128

Dichrolam™ 099
display glass 104–105
display graphics 086
domestic glassware 142, 143
Doran, Ella 020
double glazing 112–113, 124–125
drawing process 142, 143, 144, 145

Edison, Thomas 009, 029
Egyptians 016, 023, 030, 044
electrical components 143
electrical insulation 150, 151
electricity generation 088
electrochromic mirrors 090
electronic technology 086–087
engraving 100–101
Evolum Range 024–025
eyes 044–045

fabric 070–071
Fiam 014–015
fibre optics 9, 61, 64, 82
fibres 60–1, 64–5, 69, 144, 151
filament drawing 144
film coverings 136–137, 139
flame drawing 144
flat glass 142, 148
flat panel display glass 104–105
flat working 102–103
flexible glass 064–065
flint glass 151
float glass 026, 073, 103, 110, 136
Franck, Kaj 052
frosting 028
fused glass 020, 111, 123
 colour sequencing 111
 kiln-formed 111
 silica glass 072, 074, 143, 150
fused mosaics 032–033

Gentex 090
Ghost Chair 014–015
Glas Platz® 86, 87
glass beads 066, 068, 071, 135
glass ceramics 084, 150–151
glass composition 148
Glass Design 103
glass eyes 044–045
glass fibre 061, 064–066, 069, 144, 151
glass flakes 064, 066, 069, 088
Glass Sound® Loudspeakers 086–087
glass wool 061, 064
glassblowing, see blown glass
GlassFlake 069

glazing 085, 096, 109, 112, 117, 121, 125
 bullet-resistant 117
 decorative 109
 double glazing 112–113, 124–125
 film coverings 136–137, 139
 intelligent 085
 structural planks 120–121
 wired glass 096
 see also windows
Gruppe RE 138

handblown glass 046–047, 051–053, 056–057
 borosilicate glass 016, 049, 052, 062–063, 067, 069, 074,
 076–077, 105, 132
 hollow ware 052
 lead crystal 051, 074
 tableware 046–047
handformed glass 016, 018–019
heat-resistant glass
 alumino-silicate glass 064, 068, 072, 074, 084, 150
 borosilicate glass 016, 049, 052, 062–063, 067, 069, 074,
 076–077, 105, 132
 fused silica glass 072, 074
 glass ceramics 084, 151
 technical information 143
Hench, Larry 091
hollow glass beads 066, 068
hollow ware 052
holographic glass 118–119
Hong Kong Convention & Exhibition Center 128, 129
Huttner, Nicole 138

iittala 052–053
insulating glass 061, 125
intelligent glazing 085
Isotalo, Jukka 025
Izzika Tray 062

Jena Glass 048–049

kaleidoscopic panels 110
Kapilux® 125
Karen Millen store 136–137
Katayanagi, Tomu 014
kiln-formed fused glass 111
kiln-cast glass 026, 109
Koskinen, Harri 023, 052

laboratory glassware 143
Lace Construction 111
laminated glass 085–086, 103, 115–118, 128
 bent 114–115
 bullet-resistant 117
 decorative 116

holographic 118
lampworking 016, 038, 044, 063, 076
 borosilicate glass 016, 049, 052, 062–063, 067, 069, 074,
 076–077, 105, 132
 glass eyes 044–045
 glass tubes 063
 neon sculptures 038
Langley, Warren 109
lantern glass 067
laser glasses 151
lathe-working 063, 132
LCD screens 092
lead crystal 051, 074, 143
Leeds City Gallery 034–035
Lefteri, Chris 051
lemon squeezer 036–037
light 082, 090, 098, 099, 118, 128
 see also reflectivity
lightbulbs 009, 022–023, 029, 144
lighting 109, 144, 145
Lighting Design Partnership 127
Littleton, Bessie 067
London Eye 114–115
lost wax method 018
loudspeakers 086
luminous tiles 138

marbles 030–031
Marina Grande 046
Marks Barfield Architects 114
mass production 054–055
melting glass 020, 023
Mesguish, Pierre 122
micro-spheres 066, 068, 144
Millefiori bowl 032–033
Millennium Wheel 114–115
Mirogard® 134
mirrors 090, 098, 100, 132
mosaics 122
Mosaik 122
Mosquito™ 020
moulds 015, 018, 026, 033, 036, 046, 049, 051, 054–055
 borosilicate glass 016, 049, 052, 062–063, 067, 069, 074,
 076–077, 105, 132
 handblown tableware 046–047
 kiln-cast glass 026, 109
 lost wax method 018
 mass production 054–055
 Millefiori bowl 032–033
 pressed glass 036, 123, 142–145
 slumped glass 014–015
 Thick and Thin Wine Glass 050–051
Muller-Uri, Ludwig 044

Index

Multman, Zara	034–035	ribbon machine process	029, 144	Suspended Glass Tower	128–9
Murano Glass	032	road markings	068, 071, 135	Sweet Revolution range	46–7
		rods	33, 62	Tabletop Collection	74–5
Nambe	074	rolled glass	96–7	tableware	46–7
National Glass Centre	016	Romag	117	Techno Sound Wall	87
neon tubes	038–039	Royal, Richard	42	television tubes	92–3
Newnham, Rebecca	098			textile fibres	61
Newson, Marc	052–053	Saint-Gobain Glass	117	textured water	26–7
Norman Foster & Partners	112, 113	Samsonite	71	thermometer tubing	142
NV Vereenigde Glasfabrieken Leerdam	056–057	sandblasting		Thick and Thin Wine Glass	50–1
		3-D frosting	28	thin glass	104–5
Okaflex®	125	Block Lamp	23	Thomas Heatherwick Studio	126, 127
OkaSolar®	125	brilliant cutting	100	threads	60–1
Okatech®	125	flat glass	103	tiles	138
Okulux®	125	kiln-cast glass	26	toughened glass	103, 117, 126, 136
Opalux®	139	recycled bottles	25	tubes	63, 145
opaque to clear glass	085	smashed glass	116	Tungsten lightbulb	9
Operator Glass®	086	Schott	48, 63, 84, 105, 134		
optical fibres, see also fibre optics	009, 061, 064, 082–083	Scott, Otto	67, 76	U-profiled glass	120–1
optical glass	143, 151	sealing glass	151	UV bonding	103, 126–7
Ozone Glass	109	security films	139		
		security glass	117	Vello process	63
panels	104–105, 108–109, 110, 118	self-cleaning glass	78–9	Viana, Jose	46
Papadopoulos, George	116	semi-conducting effects	150	Visual Impact Technology	118
Papaloizou, Tony	017	SGG Stadip Protect	117	vitreous silica	150
Parra, Paulo	047	silvering	98, 103, 132–3	Vycor	150
passivation glass	150	sintering	143		
phosphate glass	150	slumped glass	14–15	Wagenfeld, Wilhelm	48, 49
phosphorescent coatings	135, 138	smashed glass	116	Warchold, Silke	138
photochromic glass	151	soda-lime glass	74, 76, 151	water-jet cutting	14–15, 34–5
photovoltaic glass	088–089	beads	68	wearable glass	70–1
Pilkington Activ	078–079	Block Lamp	23	windows	10, 136–7, 139
Pilkington Glass	073, 090	glass wool	61	see also glazing	
Plasma Neon technology	038	handblown tableware	46	wine glass	50–1
plastic film coverings	136–7, 139	hollow-ware	52	wired glass	96–7
Platz, Karl-Otto	086–087	lampworking	16	Wirkkala, Tapio	52
Polak, Julia	091	mass produced bottles	55	Woffenden, Emma	18
Powerglass®	086	neon sculptures	38–9	Worldwide	44
press and blow process	054–055	technical information	142, 144, 145	Worshipful Company of Glaziers and Painters of Glass	34
pressed glass	036, 123, 142, 143, 144, 145	Solar Century	88	woven rods	62
Probe Series	018–019	Solar Glas	117		
Product 2000	135	solar panels	88–9	x-ray absorption	92, 150
production methods	010	solder glass	150		
prosthetic eyes	044–045	Sousa Santos, Marco	47	Yorgos	116
Proto Design	046–047	Spaak, Ruth	111		
Pyrex	067, 076	space shuttle	72	Zanotta	62
		Spehl, Rainer	44		
quartz glass	72, 150	spheres	42–3, 66, 68, 144		
		Stanley, Jhan	16, 96, 97		
radiation	142, 151	Stevens Architectural Glass Competition	34		
Rashid, Karim	074	structural planks	120–1		
recycled glass	025, 055	studio art glass	18–19		
reflectivity	068, 071, 098, 134, 135	Sunglass	115		
Relations series, the	052	super glass	72		